IMAGES
of Aviation

GLENN H. CURTISS
AVIATION PIONEER

Dedicated to Jeanne—Mrs. Glenn Curtiss Jr.

IMAGES
of Aviation

GLENN H. CURTISS
AVIATION PIONEER

Charles R. Mitchell and Kirk W. House

ARCADIA
PUBLISHING

Copyright © 2001 by Charles R. Mitchell and Kirk W. House
ISBN 978-0-7385-0519-0

Published by Arcadia Publishing
Charleston SC, Chicago IL, Portsmouth NH, San Francisco CA

Printed in the United States of America

Library of Congress Catalog Card Number: 2001089672

For all general information contact Arcadia Publishing at:
Telephone 843-853-2070
Fax 843-853-0044
E-mail sales@arcadiapublishing.com
For customer service and orders:
Toll-Free 1-888-313-2665

Visit us on the Internet at www.arcadiapublishing.com

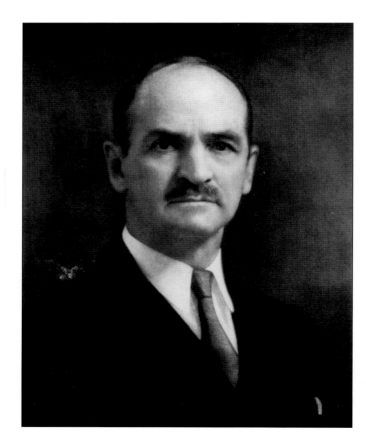

Taken late in life, this became Glenn Curtiss's favorite portrait. He liked seeing himself as a solid, successful businessman.

CONTENTS

INTRODUCTION

Glenn Hammond Curtiss received America's first pilot's license while both Wright brothers were still actively flying. His peers in the Aero Club knew him as the first man to fly an exhibition flight in the western hemisphere and as the first man to win an international air speed prize. They knew him as the man who had created the first practical float plane and the first U.S. naval aircraft. Curtiss had already earned the second pilot's license in France. He had gained permanent possession of the *Scientific American* trophy by winning it three years running. He had made the first long-distance flight in America—150 miles from Albany to New York City, with one stop for refueling. He trained pilots from across the globe in his flying schools and thrilled the crowds with his exhibition teams. He was probably the leading airplane manufacturer outside Europe.

Before his airplane days, Curtiss supplied engines for America's first airships. Before the airship days, he was one of the most successful motorcycle racers and manufacturers in the country. Before that he tinkered with bicycles, set up acetylene lamp systems, sold harness, raised rabbits, took photographs, and showed no particular signs that he was going to bust the new 20th century wide open.

He was 33 years old, had been in the airplane game for three years when he got license No. 1, and had 19 years to live. Behind him lay 18 months of association with Alexander Graham Bell. Ahead lay years of bitter lawsuits by the Wright brothers, Augustus Herring, and others, with accusations of patent theft and corporate malfeasance. The Great War would rocket him from near bankruptcy to a $6 million fortune almost overnight.

Finding the postwar aviation business "not very interesting" (and perhaps also finding it beyond his eighth-grade schooling), he would develop and market streamlined travel trailers, helping to create yet a third industry for the American century. He would develop the cities of Miami Springs and Hialeah, successfully weathering the Florida land boom and its subsequent bust. At his death he would return to his village to lie among old friend and neighbors, next to his father, his grandparents, and his infant son. Visitors from around the world often ask to see the grave site. When they do, they ask, "Is that all?"

His Hammondsport friends actually thought that the quiet monuments were too much— G.H., they said, would have found them pretentious.

Who was Glenn H. Curtiss, and where did he come from? He was born where he was buried, in the village of Hammondsport in New York's Finger Lakes region. His minister grandfather and his harness-dealer father both died when he was four; his younger sister, Rutha, went deaf at age six. Even as a child Curtiss was known for meticulous planning and unusual mechanical skill. Beginning in his teen years, he would display notable athleticism and an almost frightening sense of balance. As a teenager he lived in the big city of Rochester for several years while Rutha

attended school there. Here he finished his own schooling, and here he worked for two of the period's industrial-technical giants, Eastman Kodak and Western Union.

When his sister entered boarding school and their mother remarried, the youngster returned to Hammondsport and his beloved grandmother Curtiss. While living with her, he raced bicycles throughout the area. He married, falsifying his age, perhaps to thwart his mother's interference. Renowned as a fix-it man, he slowly turned his bicycle avocation into a career and quickly turned that career into a springboard for invention and entrepreneurship.

He and his wife had close friends, but they were both quiet people, not to be found on the village social circuit. Both rode bicycles. Both would ride motorcycles, and both would drive cars. Catching the swelling wave of internal combustion, Curtiss was in the motorcycle business (and the motorcycle-racing game) by 1901. His records and his engines made him a national figure. Alexander Graham Bell called the young junior high graduate necessary to Bell's own dreams of a practical flying machine.

Curtiss was hard to work with, for his mind was always racing. Difficult to pin down to a decision, he would stop all production in his factory to try out a new idea that had just occurred to him. Going out to rent a car for an outing one day, he returned on foot several hours later. He had forgotten why he left in the first place.

That quick mind, impatient of restraints, may have contributed to his patent problems. Legends to the contrary, he stole nothing from the Wright brothers. But some of his independent developments, while well in advance of Wright equipment and certainly worthy of their own patents, arguably fell under Wright patents. He may not have been patient enough to get this point, and even if he had, it might not have mattered. The Wrights did not want royalties from Curtiss; they wanted him out of business. So bitter did the conflict become that when Wilbur Wright died of typhoid fever in 1912, Orville Wright blamed Glenn Curtiss.

Curtiss, too, would die far too young, embroiled in a fierce courtroom case. Obituaries and memorials at the time of his death sounded a strain that would continue through the decades as friends, neighbors, colleagues, and employees looked back on the sphinxlike, meteoric figure. "Mr. Curtiss," most would remember, "was a very kind man." No one could ask for a better monument.

All photographs are used with kind permission of the Glenn Curtiss Museum, Hammondsport, New York.

One

ON THE SHORES OF KEUKA LAKE (1878–1900)

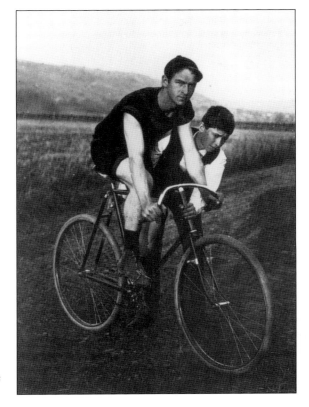

Selling bicycles from a borrowed storefront and harness from the barn in back, young Glenn Curtiss catapulted into the 20th century by mastering new technologies as soon as they appeared. Even the bicycle at the start of the century was a cutting-edge invention, bringing revolutionary independence to young Americans. Other Curtiss sidelines in his industrial incubator included a vineyard, an apple press, sewing machines, acetylene lamp systems, and even rabbit raising.

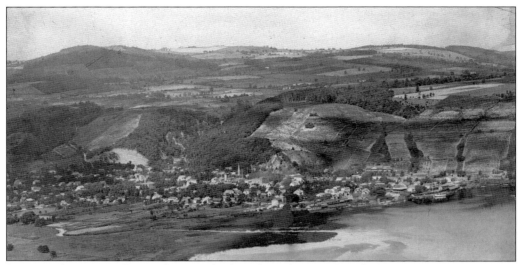

Hammondsport, on the southern end of Keuka Lake, numbered close to 1,000 souls when Curtiss was born in the Methodist parsonage on May 21, 1878. Shipping, grape growing, and wine making were the town's main businesses. The B & H Railroad, steamship docks, and vineyards are all shown in this c. 1900 scene. Kingsley Flats (foreground) would become the Hammondsport flying field.

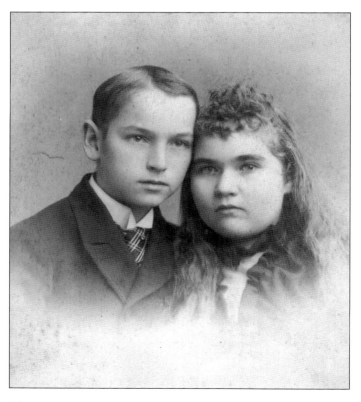

Curtiss was four when his father and grandfather died. His younger sister, Rutha, went deaf at age six. They grew up with the support of a small town and, even as a child, Curtiss became known as a careful planner who could dismantle and fix anything mechanical. Brother and sister were photographed in 1892.

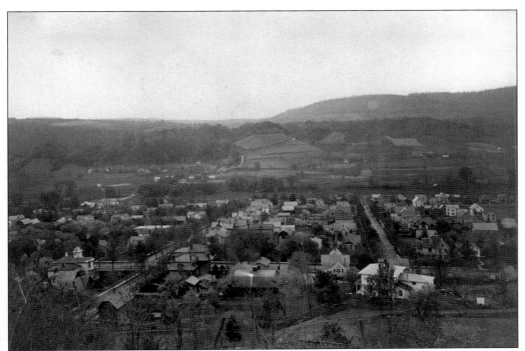

The large house in the right foreground was home to two widowed women and two small children. In Grandma Curtiss's day, the property supported a vineyard. In later years, Curtiss would surround the house with shops turning out motorcycles, engines, dirigibles, and aeroplanes. This scene looks across Hammondsport in the opposite direction from the photograph at the top of page 10.

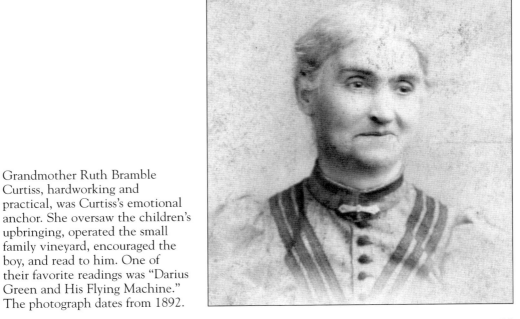

Grandmother Ruth Bramble Curtiss, hardworking and practical, was Curtiss's emotional anchor. She oversaw the children's upbringing, operated the small family vineyard, encouraged the boy, and read to him. One of their favorite readings was "Darius Green and His Flying Machine." The photograph dates from 1892.

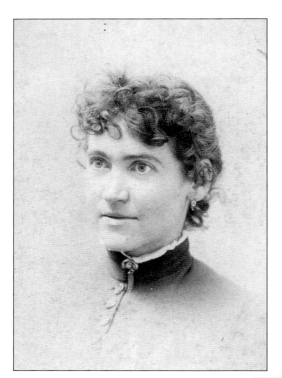

Lua Andrews Curtiss, artist and musician, was vibrant, athletic, flighty, and interfering; she exasperated her son to the end of his days. However, in his later years he showed flashes of drama and flair that he presumably inherited from his quick-witted, vivacious mother.

Lua Curtiss moved her children to Rochester, where Rutha got special schooling. Glenn finished eighth grade, grew tall and athletic, worked for Eastman Kodak, bought a bicycle, and delivered telegrams for Western Union. No one ever suggested that he had inherited any of his mother's musical talent. The instrument is probably a prop.

When Lua Curtiss remarried, Glenn (right) went back to Grandma Curtiss's for good. C. Leonard "Tank" Waters, the town's number one "wheelman," instantly recognized the "new" boy as his only superior in biking; their friendship lasted a lifetime. Waters later manufactured the Erie motorcycle, and the two were partners in the Marvel line.

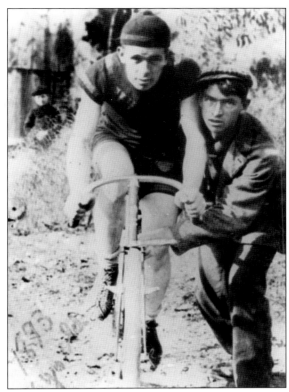

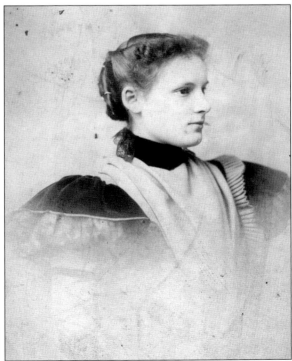

Instead of chasing girls, Curtiss stayed home with bicycle magazines. Then, while out for a bike ride one day, he found a kindred soul in Lena Pearl Neff. Quiet and hardworking like him, she also liked hiking and cycling. She would later ride motorcycles and, by 1910, purchase and drive automobiles. Curtiss likely took this photograph of his bride in her wedding dress.

13

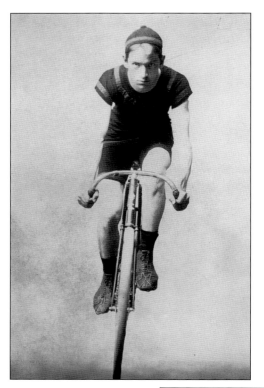

Curtiss was the star racer of the Smellie's Pep Cycle Boys when this picture was taken in 1896. Druggist Jim Smellie sponsored the team to promote his bicycle sideline. An enthusiastic Curtiss booster, Smellie would transfer the bike operation to the younger man between 1898 and 1901. Many other early aviators also started out in bikes.

Lena Pearl Neff was 17 and Glenn Curtiss just shy of 20 when they married and moved in with Grandmother Ruth Bramble Curtiss in 1898. Curtiss worked part-time as a photographer and probably took this betrothal photograph as a self-portrait. He did odd jobs, won bicycle races, raised rabbits, and no doubt helped in the vineyard. He needed something steady.

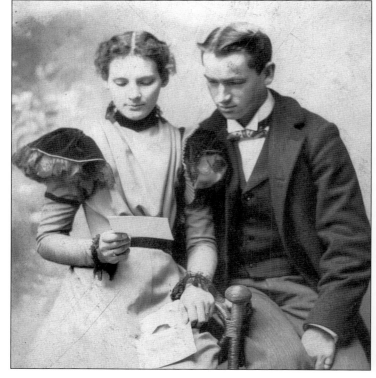

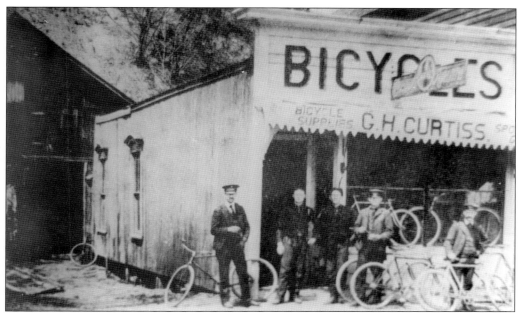

Curtiss always fixed the other fellows' bicycles—so why not make a business of it? Under Jim Smellie's sponsorship, Curtiss (left) went into parts and service. Businesswoman Malinda Bennitt, who had watched him grow up, lent him a storefront on Hammondsport's Pulteney Square. The building no longer stands, but a reproduction of the facade is in the Curtiss Museum.

Now a respectable businessman, young Mr. Curtiss cultivated a distinguished mustache and a number of sidelines. For this portrait with Lena, Charles Green, and a friend, Curtiss reprised his short career with Saylor studio. He is squeezing a bulb to take a self-portrait; note the blur where the hose twitched.

15

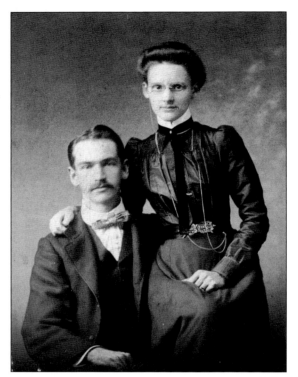

Curtiss probably took this photograph of himself and his wife before the birth of their first child in 1901. He bought out Jim Smellie's sales agencies in 1901, opening seasonal branch stores in nearby Bath and Corning. He became a sidepath commissioner, charged with collecting fees, issuing licenses, and maintaining the roadside bike trail from Hammondsport to Bath. He even started manufacturing his own machines, using a contractor in Addison.

Carlton Curtiss, born in 1901, died a month before his first birthday. The family was devastated and, to make matters worse, it was clear that they would soon be losing Grandma Curtiss and Lena's father. Lena Curtiss assuaged her grief by taking a hand in the office side of the business. Curtiss threw himself into a new technology and into a new thrill that he had discovered just about the time of his son's birth.

Two

MOTORCYCLES: "THAT AMAZING MR. CURTISS" (1901–1907)

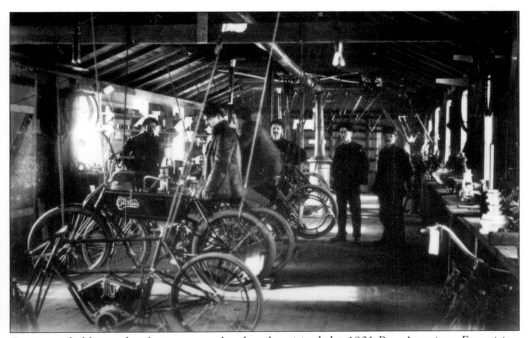

Curtiss probably saw his first motorcycle when he visited the 1901 Pan-American Exposition in Buffalo in June. He made his first machine almost immediately afterward, using a bicycle frame, a mail-order engine, and a tomato-can carburetor. Legend says that he drove into the lake, having forgotten brakes. History tells us that he quickly became one of the country's most famous motorcycle men, turning Hammondsport into a busy manufacturing town and even sending his power plants into the sky.

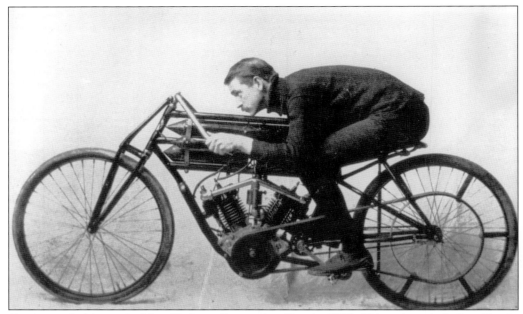

Curtiss made history in New York on Decoration Day in 1903. Using America's first V-twin motorcycle, he won a hill climb, a 10-mile race, and the American Amateur Championship, meantime setting a new mile speed record. The torpedo tanks were a feature of his early Hercules design. The racing crouch was almost a Curtiss trademark.

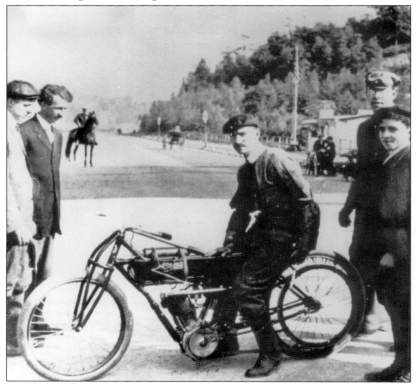

Correct dress was expected even for motorcycle racers. Can you imagine a motorcycle racer today wearing a suit?

On the other hand, America had almost no paved roads back then. Leather suits were essential.

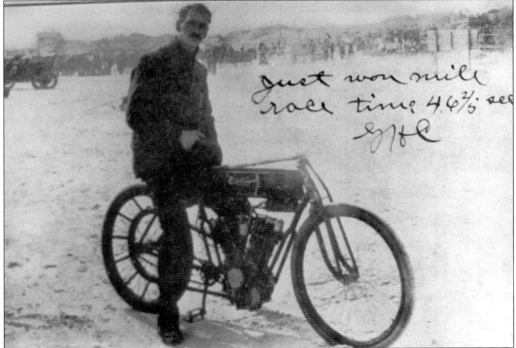

Just won mile race time 4.6⅗ sec

Even victory was not enough to make G.H. crack a smile. This is a standard-frame (also called O-frame) model. The horizontal tank holds gas, with a smaller oil reservoir faired right in near the seat. The original flat belt has given way to a segmented V-belt, and the engine is a V-twin.

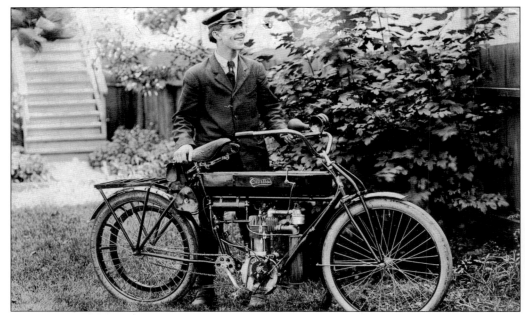

Someone mailed this postcard from Chicago to the Curtiss Company, without any message, in 1907. We do not know who the young fellow is, but he is clearly very happy with his new Curtiss.

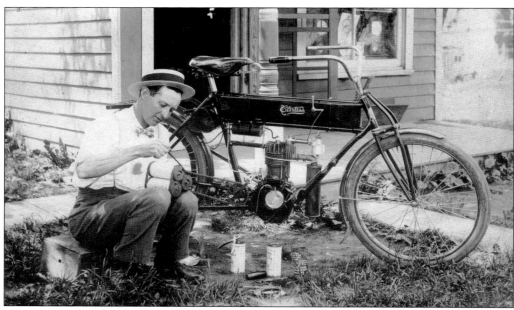

Batteries fit into a compartment behind the seat. The pedals helped with ignition spark, assisted on hills, and took over when gas ran out or engines broke down.

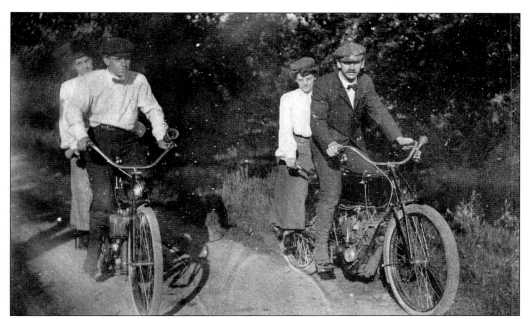

Bicycling couples often became motorcycling couples. Mr. and Mrs. Tank Waters and Mr. and Mrs. Glenn Curtiss seem to be enjoying their outing. The only surviving Curtiss tandem is now in the Otis Chandler Vintage Museum, Oxnard, California.

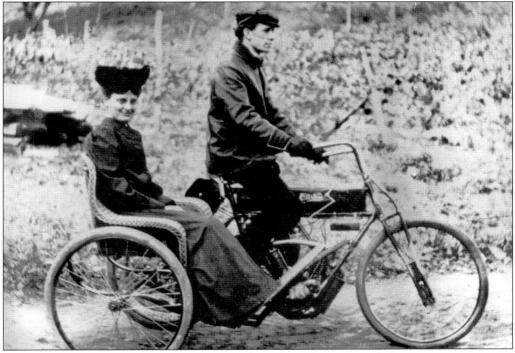

The wicker sidecar attachment listed for $50 throughout the whole Curtiss motorcycle manufacturing period. Lena Curtiss, riding with Tank Waters, has very little protection against mud and none at all against sudden stops.

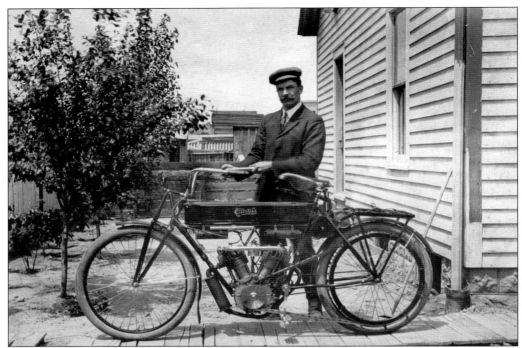

Hercules was the Curtiss brand until another firm claimed prior usage of the name. After some argument, Curtiss finally adopted his own name as the trademark. The Curtiss script was not based on Curtiss's signature. It was designed by Claude C. Jenkins, an employee in the Curtiss plant, who painted as a sideline and spent most of his life as a barber in Hammondsport.

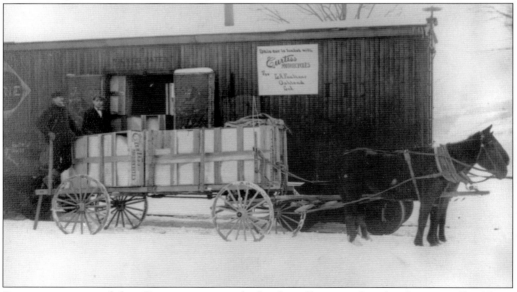

Business was so good that Curtiss sometimes had to lay off even cash orders because of backlogs. Here is a marvelous juxtaposition of changing technologies: a horse-drawn dray hauling gas-powered motorcycles to the steam-powered railroad. Notice that one dealer in California is taking the whole carload.

"Captain" Thomas Scott Baldwin, acrobat, aeronaut, and parachutist, was always looking to top his own acts. In 1904, he was ready to try his airship at the St. Louis World's Fair—powered by a lightweight, high-output Curtiss motorcycle engine. Baldwin's nonrigid dirigible, the *California Arrow*, worked (a western hemisphere first) and even flew a circle.

Thomas Baldwin hustled to Hammondsport to sell the bemused Mr. Curtiss on aeronautics. Curtiss was not very interested but appreciated the new engine market. The two daredevils, so different in age and temperament, grew very close. Baldwin moved into Curtiss's home, adding balloons and dirigibles to the manufactures of Hammondsport.

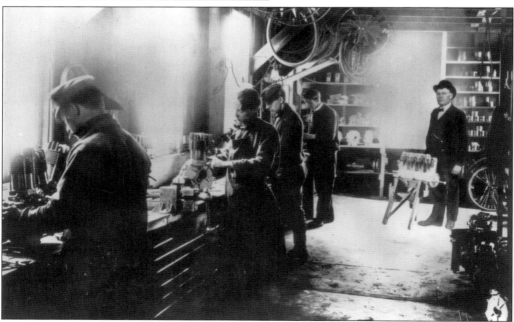

Thomas Baldwin relied exclusively on Curtiss engines in those days, driving creation of an air-cooled four-cylinder in-line for greater power. The single-cylinder, the V-twin, and the straight four all employed the same cylinders.

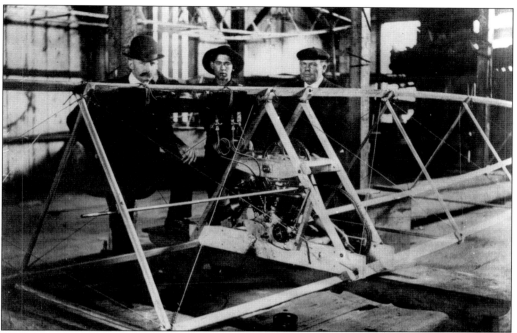

Thomas Baldwin's dirigible shop was on Kingsley Flats, adjoining the village on Keuka Lake.

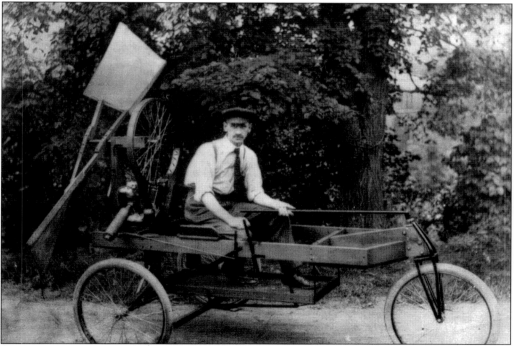

Glenn Curtiss and Thomas Baldwin both tended to be "seat-of-the-pants" men, not given much to modeling or mathematical projections. Curtiss designed a Wind Wagon with a motorcycle engine to test dirigible propellers. He even sold a few as road vehicles, despite the fact that they caused "a riot among the equine contingent."

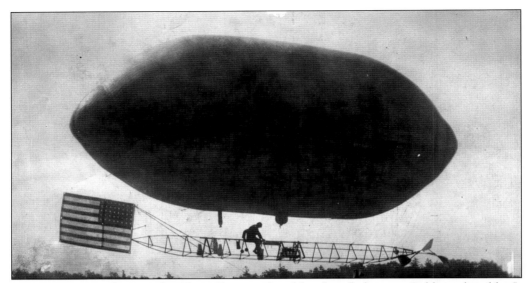

In June 1907 on the Kingsley Flats, Curtiss piloted his first flight, in a Baldwin dirigible. It changed his life. Never again would he consider flying men as crackpots. When he finally came down, he announced that he thought he could make it go faster.

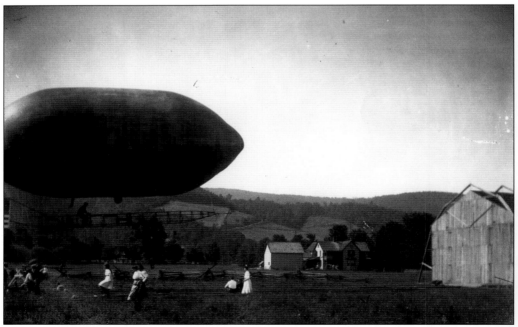

The pilot controlled pitch (nosing up or down) by shuffling back and forth on the gondola, thus shifting the center of gravity.

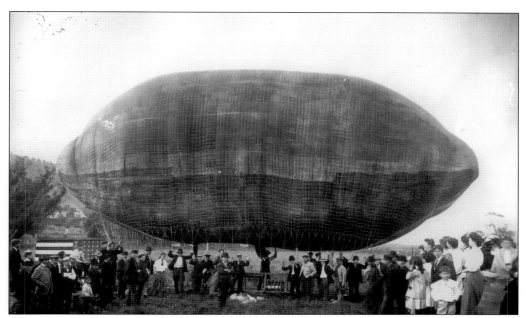

These lighter-than-air craft drew great crowds wherever they went, especially on a Sunday. Note the sandbags for ballast. The flag is actually the rudder.

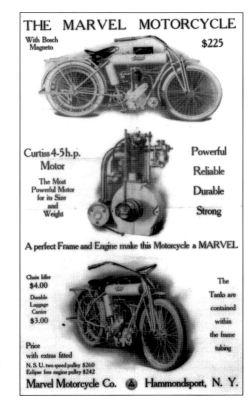

THE MARVEL MOTORCYCLE

With Bosch Magneto — $225

Curtiss 4-5 h.p. Motor

The Most Powerful Motor for its Size and Weight

Powerful
Reliable
Durable
Strong

A perfect Frame and Engine make this Motorcycle a MARVEL

Chain Idler $4.00

Durable Luggage Carrier $3.00

Price with extras fitted
N.S.U. two speed pulley $260
Eclipse free engine pulley $242

The Tanks are contained within the frame tubing

Marvel Motorcycle Co. Hammondsport, N. Y.

After 1912, Curtiss dropped his name from motorcycles. He and Tank Waters jointly manufactured the Marvel until 1914, when total-war airplane orders ended Curtiss's involvement in motorcycles for good.

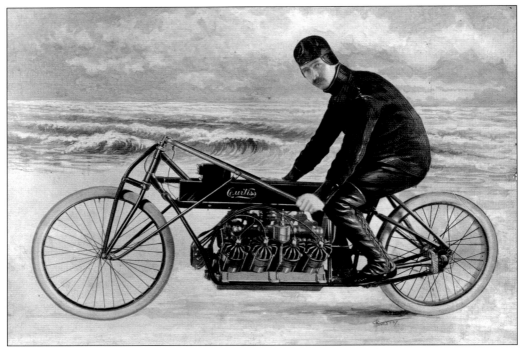

The climax of Curtiss's racing career came at Ormond Beach, Florida, in January 1907. Using one of his new airship engines to power the world's first V-8 motorcycle, he shattered the mile in $26^2/5$ seconds—better than 136 mph. Not even a locomotive had ever beaten that time. He was "the fastest man on earth."

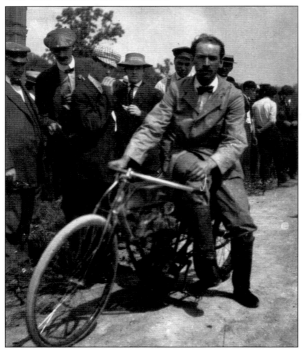

When Curtiss was injured racing at Providence, Rhode Island in July 1907, his wife insisted that he give up competition. Curtiss agreed; yet another technology was attracting his attention.

Three

THE AERIAL EXPERIMENT
ASSOCIATION
(1908–1909)

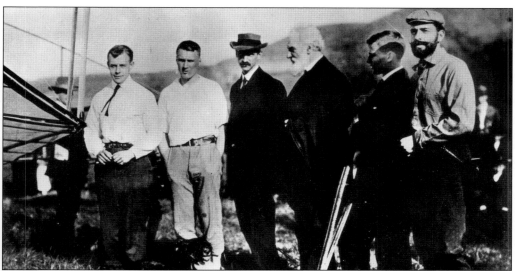

Hammondsport became "an aeroplane laboratory" in 1908. Dr. Alexander Graham Bell stayed in the Curtiss home (annoyed by the constantly ringing telephone) as he oversaw the work of his Aerial Experiment Association (AEA). If Bell had been born wealthy, he might never have bothered with telephones; even as a child, he was fascinated by flight. By 1907, he had tired of waiting for details and demonstrations from the Wright brothers. Why not assemble a team of his own to tackle the problems of practical flight? The AEA (shown here with *White Wing*) comprised, from left to right, F.W. "Casey" Baldwin (no relation to Thomas Baldwin), chief engineer; U.S. Army Lt. Thomas E. Selfridge, secretary; Glenn Curtiss, director of experiments; Alexander Graham Bell, chairman; and J.A.D. McCurdy, treasurer. Also in the photograph are Augustus Post of the Aero Club and Selfridge's dog Jack.

Mabel Bell put up money for a new research team, and Alexander Graham Bell determined to recruit Curtiss, a "well known expert" in motors. Curtiss, who was running a busy motorcycle plant, needed considerable convincing before agreeing to take up flying machines. Mrs. Bell was deaf, and Curtiss's experience with Rutha allowed them to communicate readily.

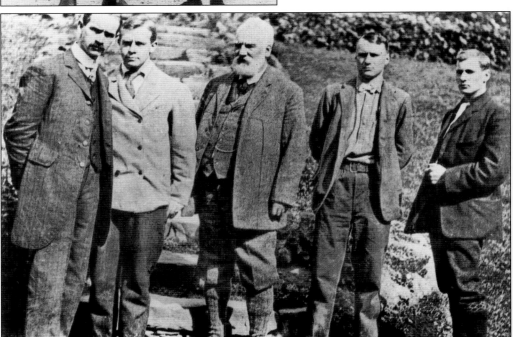

The Aerial Experiment Association's mission, defined by Thomas Selfridge, was simple: "To get into the air." Curtiss, between Alexander Graham Bell and the others in age, felt a little awkward among these university men. This photograph was shot at Bell's summer home on Cape Breton Island, now a Canadian National Historic Site. Pictured, from left to right, are Curtiss, Casey Baldwin, Bell, Selfridge, and J.A.D. McCurdy.

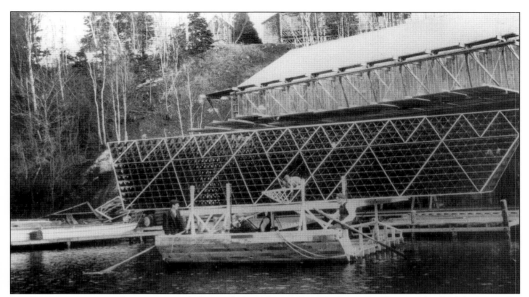

"Bell's Boys" instantly recognized that while Alexander Graham Bell's tetrahedral kite might work, it would never be practical. When it was wrecked on a trial flight in Nova Scotia, they seized the opportunity to move operations to Hammondsport and concentrate on aerodromes, or airplanes, which not one of them had ever seen. Bell, with decades of patent struggles behind him, insisted on thorough photo-documentation.

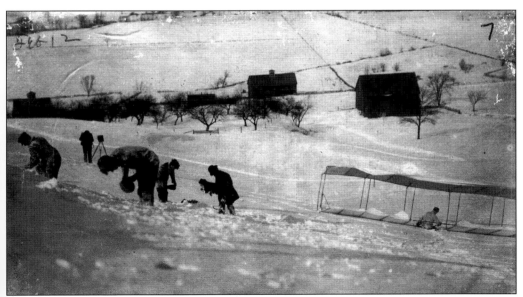

In early 1908, experiments began with a Chanute-type hang glider, conducted on the slopes across the road from the modern Curtiss museum. This February 12, 1908 photograph shows a camera set up facing the one that took the picture.

They invented the aircraft carrier before they flew their first airplane. The steam barge *Springstead* ferried AEA No. 1, *Red Wing*, to solid ice on Keuka Lake.

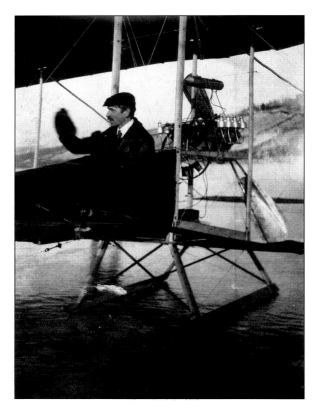

Curtiss checks the aerodrome prior to flight. Aerial Experiment Association members took turns as lead designer, with all members participating in the work, along with Curtiss staff, Bell staff, and independent kibitzers such as Thomas Baldwin. Each design built on experience gained with its predecessors. *Red Wing* was Thomas Selfridge's brainchild.

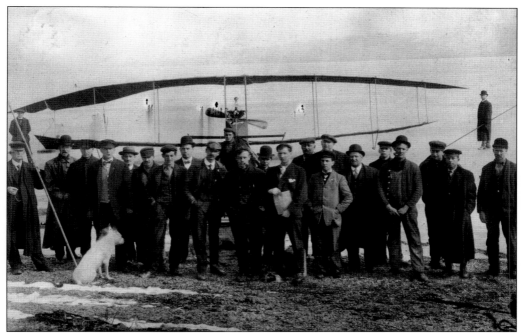

The Wright brothers tended to keep their work under wraps for patent purposes, but the Aerial Experiment Association was more open about its operations. Former photographer Curtiss quickly grasped the value of Alexander Graham Bell's photo-documentation. Hammondsport cameraman Harry M. Benner, who snapped this photograph, became the semiofficial Curtiss photographer. The public devoured Benner's postcards and portfolios. His work is an unparalleled resource on early aviation.

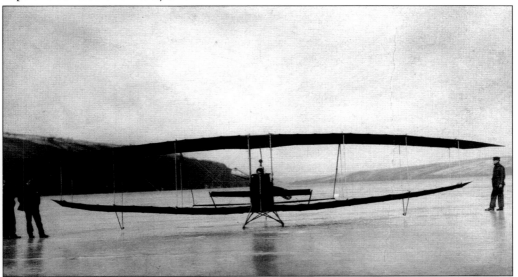

Thomas Selfridge was away on army business, and Curtiss stressed that the ice would not last. On March 12, 1908, Casey Baldwin made the first western hemisphere flight outside the Wright camp. The 318-foot trip was the longest first flight yet accomplished by a heavier-than-air craft.

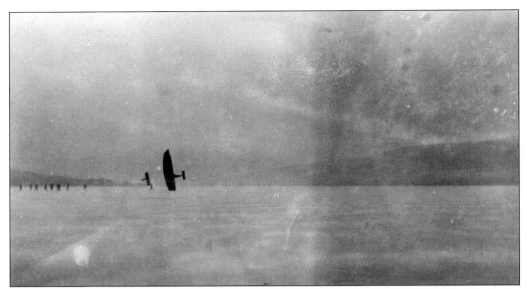

Casey Baldwin, despite his lucky green tie, wrecked *Red Wing* in its second flight on St. Patrick's Day; Thomas Selfridge never saw it fly. Members of the team recognized that they needed a system of lateral control, which Drome No. 1 had lacked.

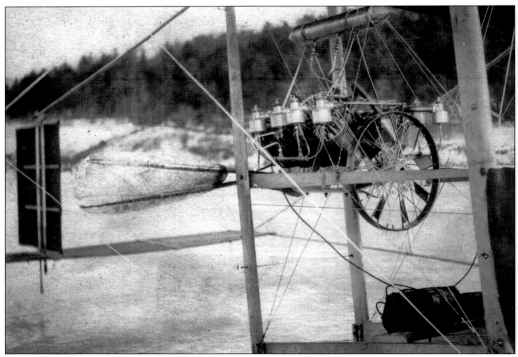

On the other hand, Curtiss's 40-horsepower, 175-pound air-cooled V8 engine—the same type used on his 1907 monster motorcycle—was an unqualified success.

Thomas Baldwin was only one of several aviation dreamers in town to take advantage of Curtiss engines, and all those busy brains made a zesty mix. Typewriter manufacturer J.N. Williams (in fez) was working on a helicopter, which lifted a man in tethered flight but had no means of control. Curtiss took this photograph in May 1908.

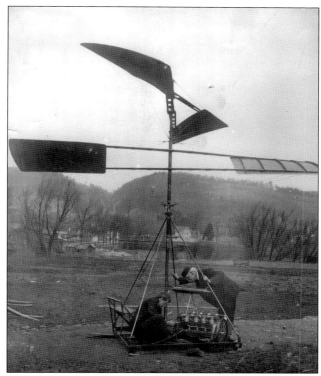

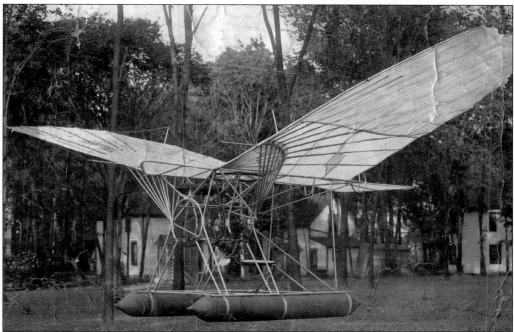

H.C. Gammeter's ornithopter, a wing flapper, took off in unmanned tethered flight but never progressed any further. The original photograph is printed on canvas and measures 8 inches by 12^1/$_4$ inches.

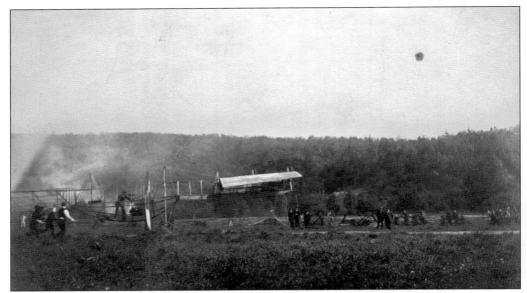

Charles Oliver Jones, artist and Socialist lecturer from the Midwest, never got his ornithopter off the ground. Switching to lighter-than-air, Jones would be killed in September 1908, when his airship caught fire in Maine.

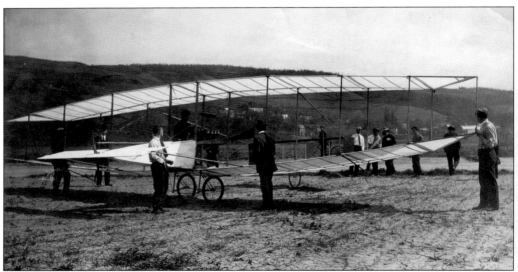

Casey Baldwin took the lead for Drome No. 2, *White Wing*. This aircraft originated tricycle landing gear, apparently borrowed from the Curtiss Wind Wagon. It handled lateral control by sporting the first ailerons in America—those triangular flaps at the wing tips. The tail section had been salvaged from *Red Wing*.

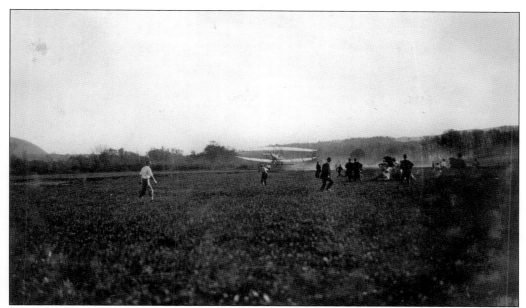

Casey Baldwin and Thomas Selfridge each flew *White Wing* before Curtiss celebrated his 30th birthday by piloting his first airplane flight. He covered over 1,000 feet in two hops, startling even the "experienced" pilots with his control. When J.A.D. McCurdy wrecked *White Wing* on his first flight, it was Curtiss's turn to take the lead.

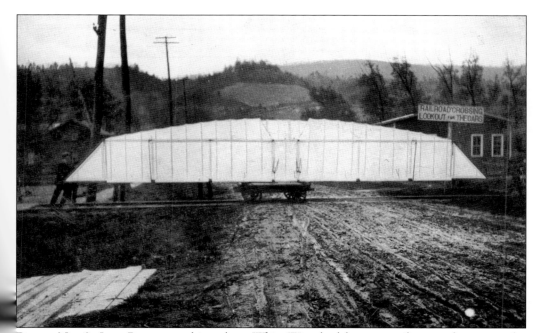

Drome No. 3, *June Bug* , was shipped, as *White Wing* had been, a mile out of town to the hamlet of Pleasant Valley. Here, vintner Harry Champlin had made his barn and trotting track available as a flying field.

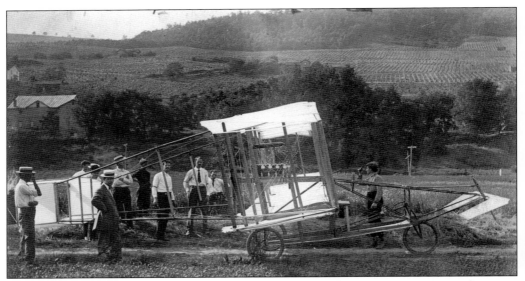

Structural improvements from *White Wing* seemed minimal, but improvement in performance was dramatic. Wary of another wreck, the team decided that no one but Curtiss would fly *June Bug* until they were satisfied that they had squeezed from it all the knowledge they could.

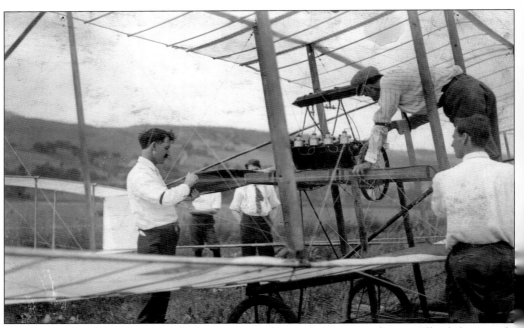

Ties and dress shirts were standard wear even for working on airplanes. All of these early machines were pushers, with the propeller in the stern driving forward. The cylinder above the engine is a gas tank.

June Bug was so successful that the team determined to try for the *Scientific American* trophy for an unassisted takeoff followed by a one-kilometer straight flight. "Advertise it," said Curtiss. "Prove to the world that we can really fly." July 4, 1908, was to see the first exhibition flight and the first officially observed trial in the Americas.

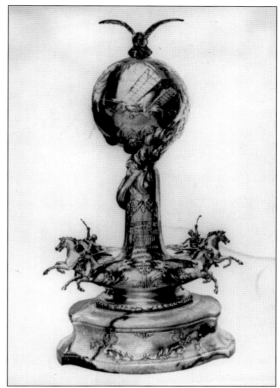

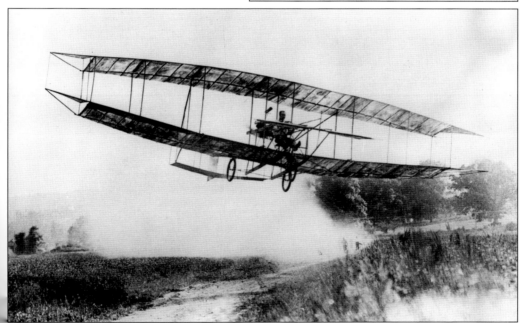

"Man flies!" wrote Alexander Graham Bell's son-in-law. On hand were 1,000 people, including representatives of the Aero Club, *Scientific American,* and even a movie crew, for the first film of an American airplane.

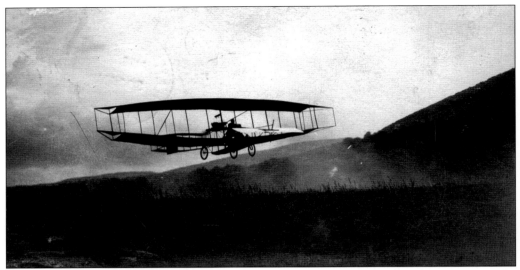

This flight, with all its publicity, forced airplanes into the American consciousness. The message on this original Benner postcard reads, "A big bug. Aunt J."

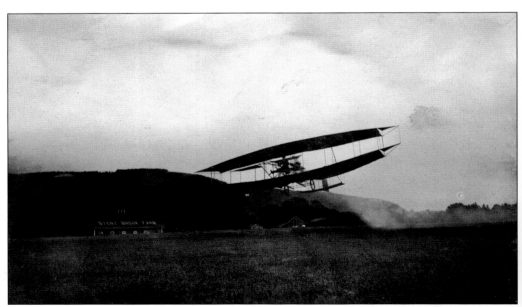

Curtiss covered almost a mile before his engine overheated. Harry Champlin's famous barn, as well as his Pleasant Valley Wine Company, still stand in Hammondsport on grounds now owned by Mercury Aircraft.

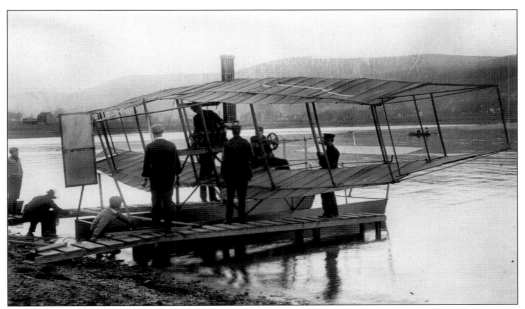

J.A.D. McCurdy, living in the Curtiss home, started design work on Drome No. 4 as Casey Baldwin returned to Nova Scotia for more tetrahedral kite work with Alexander Graham Bell. Curtiss and McCurdy put floats on *June Bug*, rechristened her *Loon*, and tried out water flying. It did not work, and Curtiss would need another 26 months to crack the problem.

One dark night, J.A.D. McCurdy unwittingly broke a float, sinking *Loon* in what he and Curtiss described as a moonlight vaudeville performance. The irreverent pair wired Alexander Graham Bell: "Submarine test most successful."

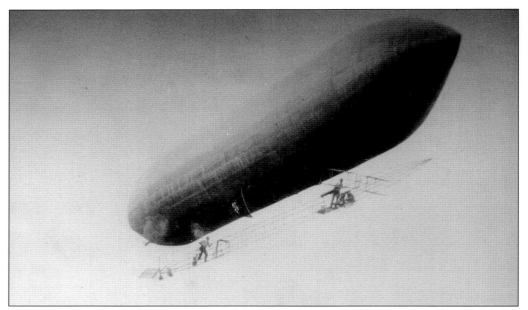

Thomas Baldwin had a U.S. Army Signal Corps contract to build the biggest flying machine America had ever seen, with a purpose-built four-cylinder in-line water-cooled engine from Curtiss. Heading for Fort Myer in August, the two Hammondsport colleagues erected the huge dirigible. Pilot Baldwin, in the stern, operated the rudder. Flight engineer Curtiss, in the bow, operated the engine and the biplane elevator, which would be copied for AEA No. 4.

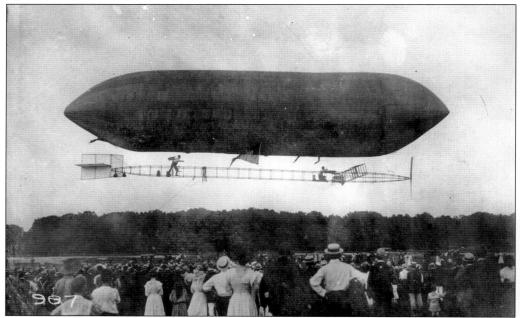

Thomas Baldwin and Glenn Curtiss conducted acceptance trials, flying over two hours and more than 25 miles. America had an air force, built in Hammondsport, and reporters in Washington celebrated with Hammondsport Great Western champagne. Army aviation pioneers Benjamin Foulois and Frank Lahm would both learn to fly on Baldwin's *SC-1*.

The army was also testing a Wright aeroplane. Orville Wright was disgusted to find Curtiss colleague Thomas Selfridge on the acceptance board but took him up for trials on September 17, 1908. A propeller split, the airplane was wrecked, and Wright was fearfully injured. Selfridge, shown in *White Wing*, was the first man to die in an airplane crash.

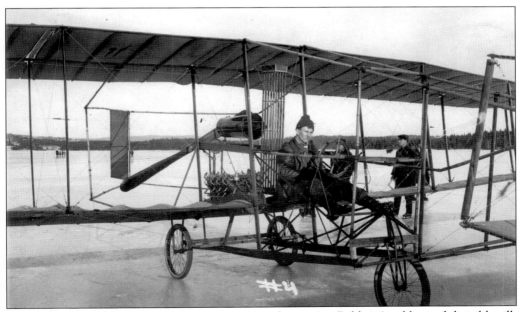

The shaken Aerial Experiment Association carried on, using Baldwin's rubberized dirigible silk to cover the wings of Drome No. 4, *Silver Dart*. With a goal of advancing the flying time "from minutes to hours," *Silver Dart* sported chain drive and a new Curtiss V8 water-cooled engine. Those standing pipes are the radiator.

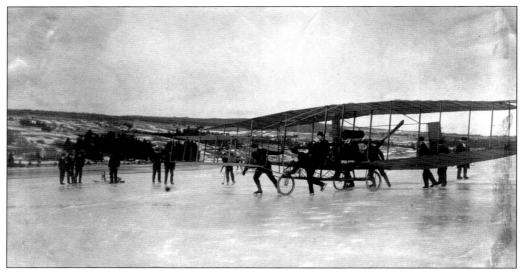

Other innovations were the enlarged biplane elevator and the elimination of the horizontal stabilizer. J.A.D. McCurdy wanted an airplane that would respond more sensitively, which, of course, made it less inherently stable. He said that *Silver Dart* had been "built like a watch" in the Curtiss plant.

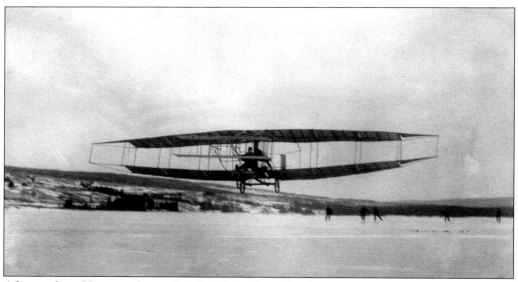

After trials at Hammondsport, J.A.D. McCurdy took *Silver Dart* from the ice in Nova Scotia (February 23, 1909) for the first heavier-than-air flight in the British Empire. Later that week, he flew more than four miles. The Aerial Experiment Association's work was triumphantly done, and its charter was about to expire. Alexander Graham Bell was eager to keep the group together, but Glenn Curtiss had other plans.

Four

THE KING OF THE AIR (1909–1914)

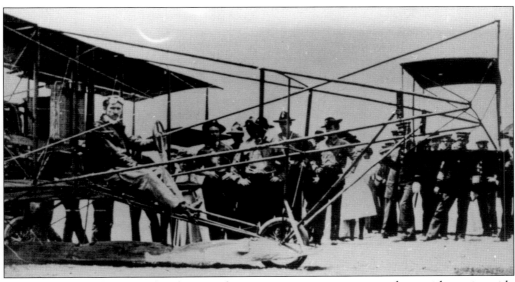

Glenn Curtiss, who was already manufacturing a transportation product with nationwide distribution, was eager to start manufacturing airplanes. Abandoning the Aerial Experiment Association, he entered an ill-starred partnership with Augustus Herring. Despite his early work with Octave Chanute and his scientific writing on flight, Herring had produced little but promises in the previous decade. Now he promised cash, factory equipment, and patents predating those of the Wright brothers. All three proved nonexistent. Curtiss and the other Hammondsport directors forced the company into bankruptcy. Curtiss bought the assets (including his own house) at auction and started all over again. The badly managed bankruptcy would still be plaguing Lena Curtiss after her husband's death. As he had done with motorcycles, Curtiss promoted his product with personal daring. Always questing for innovations, for new applications, and even for more efficient shipping, Curtiss quickly thrust forward to become the leading manufacturer, and the leading birdman, in the Americas. This provoked another series of bitter lawsuits—this time from the Wright brothers.

With his tie, his soft collar, rolled-up sleeves, quiet demeanor, and clear, piercing eyes, young Mr. Curtiss seemed the very exemplar of the new American inventor.

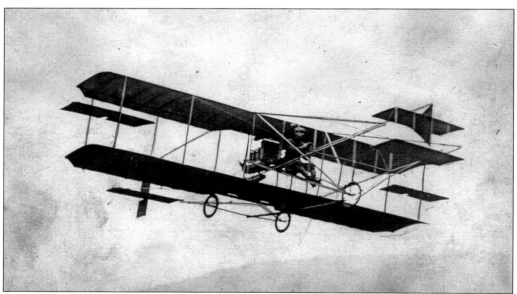

Between the Aerial Experiment Association and Herring partnerships, Curtiss contracted for America's first airplane sale. *Gold Bug* was a distinct improvement on the AEA machines. It was far smaller, with Chanute-type biplane wings, at once simpler and more efficient. The wing fabric was rubberized, as in *Silver Dart*.

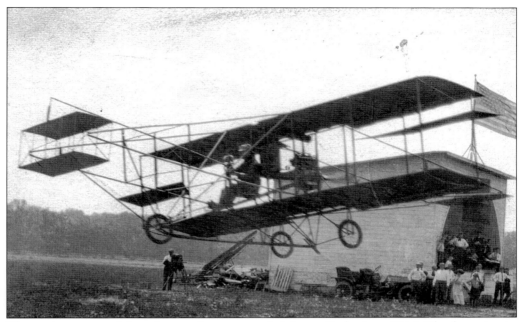

The engine was an elaboration on the water-cooled four-cylinder from *SC-1*. The four wingtip ailerons became two interwing ailerons, mounted on the leading struts. Part of the thinking behind this change may have been an attempt to avoid the Wright wing-warping patent.

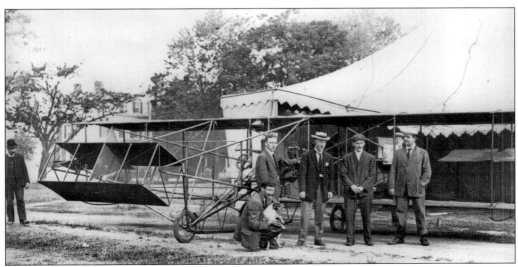

Gold Bug (Curtiss No. 1) cost the New York Aero Club $5,000, including delivery and flight instruction for two members. The gentlemanly club renamed their new possession *Golden Flier*.

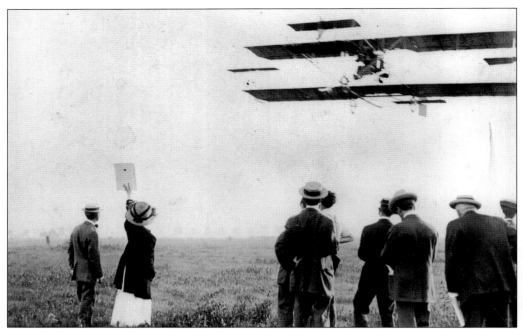

On July 17, 1909, scarcely a year after his *June Bug* triumph, Curtiss flew *Golden Flier* 24.7 miles in a circular course, handily beating the 25-kilometer requirement for 1910's *Scientific American* trophy. Charles Manly's sister held up numbered placards indicating each lap as he passed.

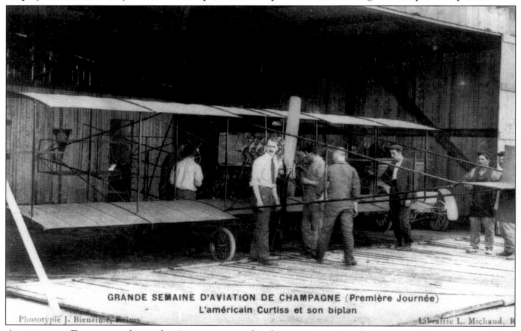

GRANDE SEMAINE D'AVIATION DE CHAMPAGNE (Première Journée)
L'américain Curtiss et son biplan

Phototypie J. Bienaimé, Reims Librairie L. Michaud, F

Arriving in France as the only American in the first international air meet, Curtiss assembled his No. 2 machine, which he had finished so hastily that it was as yet unflown. He raised French eyebrows by rolling up his sleeves and working alongside the mechanics. Curtiss mailed this postcard to a Hammondsport friend with a witty remark about French currency.

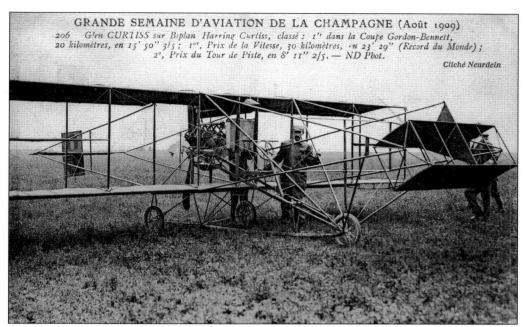

Curtiss's lightweight machine had a daring 50-horsepower water-cooled engine.

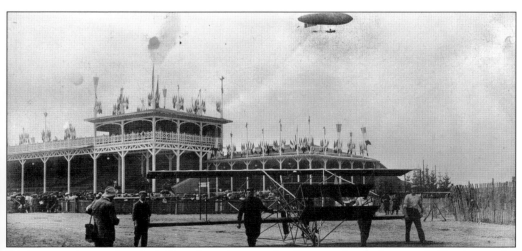

Diving to gain speed and circling the pylons so closely as to shock the crowd, Curtiss set the world air speed record at 46¹/₂ mph. The ecstatic French, proclaiming Curtiss "the Champion Aviator of the World," gave him pilot's license No. 2.

The elaborate reception he got on returning to Hammondsport took Curtiss aback. He had won $15,000 from flights in France and Italy. He gave $500 to "an elderly widow" (probably Malinda Bennitt) who had helped him out when he started in business. Another $5,000 or so went to his wife, who bought an electric car.

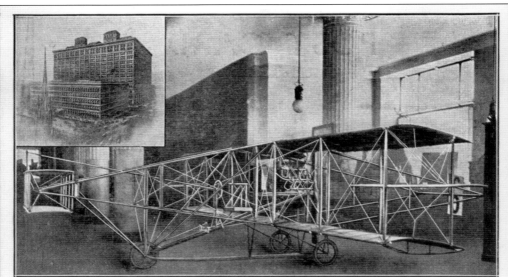

AT WANAMAKER'S, TO-DAY, WE SAW THE HERRING-CURTISS FLYING MACHINE THAT WON THE CHAMPIONSHIP.

Without Curtiss's knowledge, partner Augustus Herring had contracted with Wanamaker's and Filene's department stores for a total of $9,000 to show the *Rheims Racer*. Tying up the machine—and especially its engine—cast a pall on Curtiss's next exhibition.

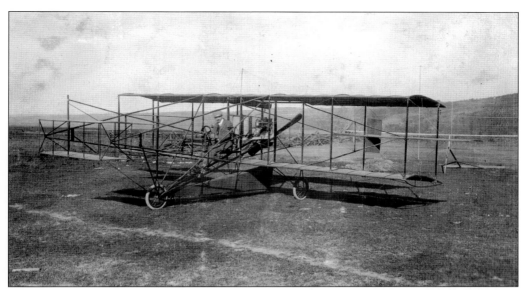

To meet his deadline for the Hudson-Fulton Celebration, Curtiss had to use one of his four-cylinder motors. Plagued by bad weather and unhappy with his engine, Curtiss made only unimpressive flights, in sharp contrast to the performance of Wilbur Wright. The wedge-shaped box on the undercarriage is a safety float.

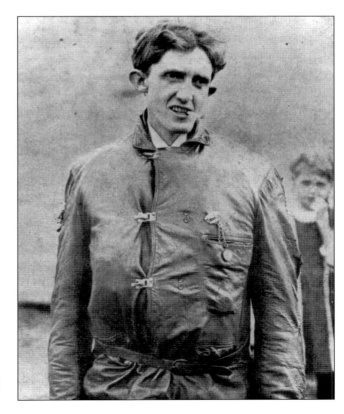

Charley Hamilton, tiny, tubercular, and wild, took lessons from Curtiss and became his first contract flier.

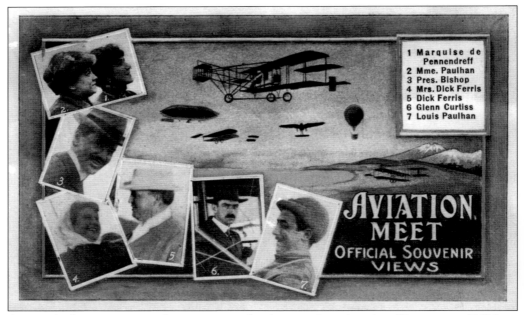

America's first international air meet took place at Los Angeles (Dominguez Hills) in January 1910.

Glenn Curtiss and Louis Paulhan renewed the friendship they had formed in France despite the lack of a common tongue. Both quickly fell afoul of Wright patent suits.

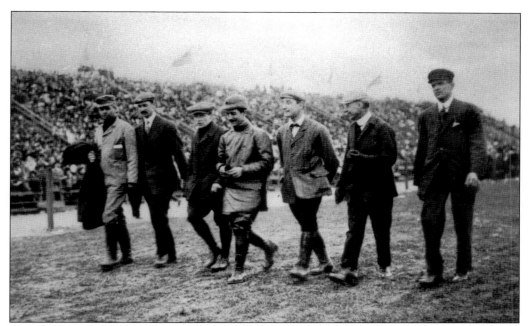

America had never seen such a gathering of airmen. Curtiss took prizes for air speed, speed with a passenger, and speed of takeoff. Shown, from left to right, are Aviator Smith, Glenn Curtiss, Didier Masson, Louis Paulhan, Charles Miscarol, Charles F. Willard, and Lincoln Beachey.

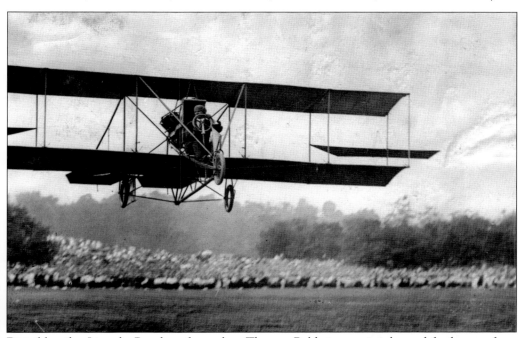

Dirigible pilot Lincoln Beachey, formerly a Thomas Baldwin protégé, begged for lessons from Curtiss. No one could figure out why Curtiss kept Lincoln around, considering the rate he went through airplanes. But Curtiss discerned the man who was fitfully emerging—perhaps the greatest pilot of the age.

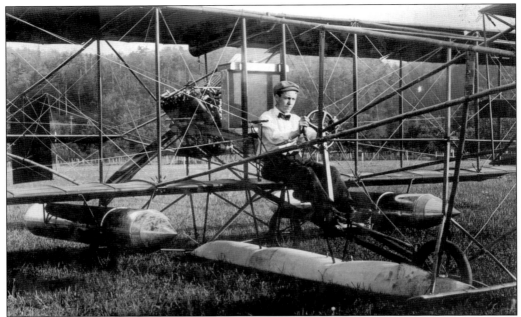

Curtiss forced Augustus Herring out in early 1910, perhaps hedging his bets by quiet arrangements with old friend Tank Waters, who was moving his Erie Motorcycle Company from Buffalo to Hammondsport. Determined again to seize his lead in aeronautics, Curtiss prepared a new machine, with a makeshift canvas float.

Assembling his new bird at Albany, Curtiss watched the weather in frustration for several days.

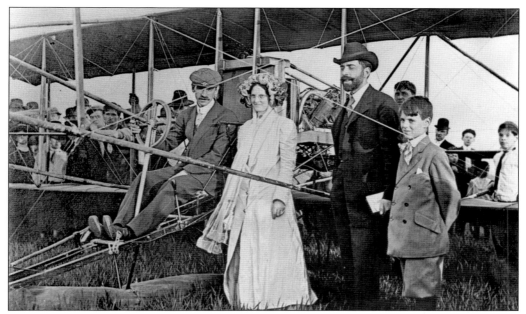

Lena Curtiss was with her husband on May 29, 1910, as were Curtiss's young half-brother G. Carl Adams and Augustus Post of the Aero Club, posing for news cameras as crowds awaited the flight.

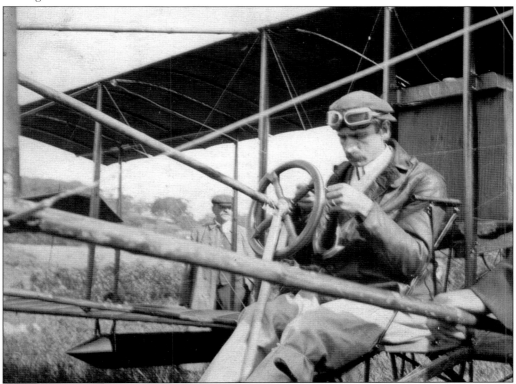

At last Curtiss was ready for the 150-mile flight to New York, with one stop for refueling.

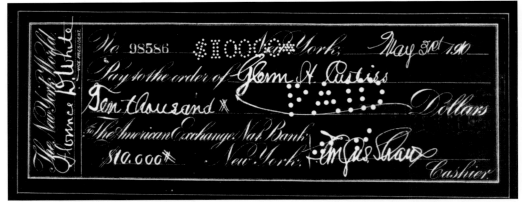

Three hours and 22 minutes later, besides the $10,000 prize, he earned the *Scientific American* trophy for the third year running; no one else ever won it at all. The trophy, which was retired to Curtiss, is now on view at the National Air and Space Museum.

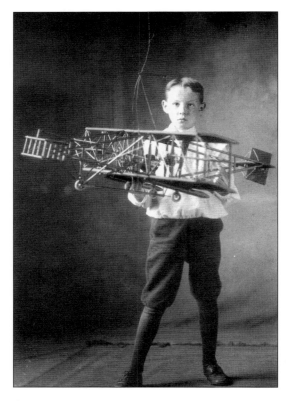

Claude C. Jenkins, who had designed the Curtiss trademark, crafted this *Albany Flier* model, now in the Curtiss Museum collection. Holding the model is James F. Jenkins, son of the maker.

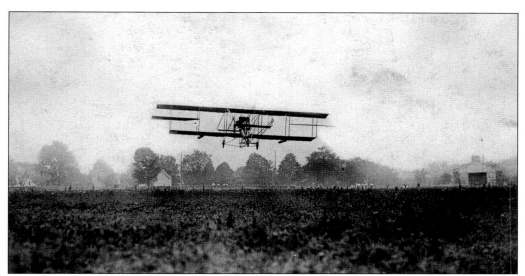

In June 1910, Curtiss tried dropping "bombs" on a "battleship" outlined in Keuka Lake. He scored 15 hits and a near miss with 17 tries, but of course the target was neither maneuvering nor returning fire. Nevertheless, Curtiss observed that when an airplane costing a few thousands could sink a battleship costing millions, there would be "some change" in the composition of navies.

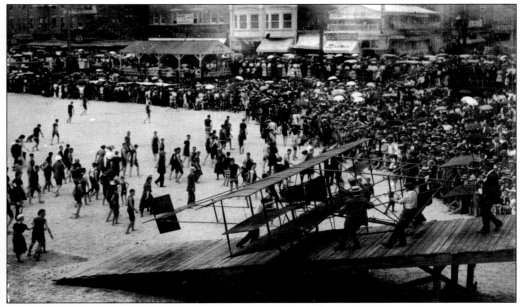

In July 1910, Curtiss won a 50-mile over-water race at Atlantic City.

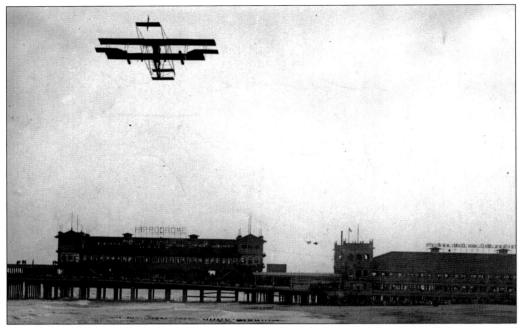

French aviator Louis Blériot had already flown the English Channel, but ocean flights were still considered shocking.

Needless to say, it was a popular event. In 1910, so few people had seen an aeroplane that large crowds were guaranteed whenever one appeared.

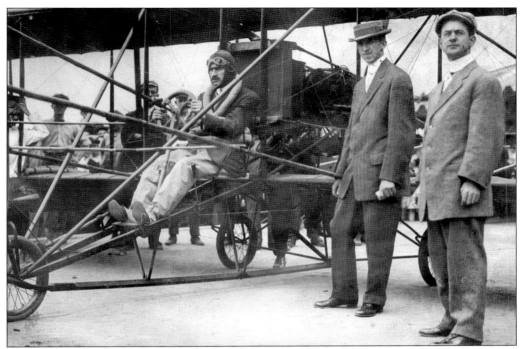

In August 1910, Curtiss set a world over-water record, 64³/₄ miles up Lake Erie from Cleveland to Sandusky, Ohio. Notice the shoulder yoke to engage ailerons. Do you think the inner tubes would have been much help?

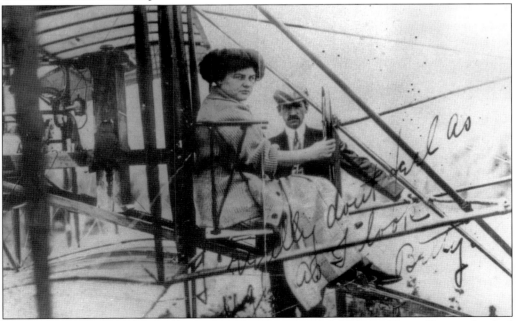

In the fall of 1910, Curtiss and other employees instructed Blanche Stuart Scott, who had already driven an automobile coast to coast. Most scholars consider "Betty" Scott, "Tomboy of the Air," the first woman pilot in America.

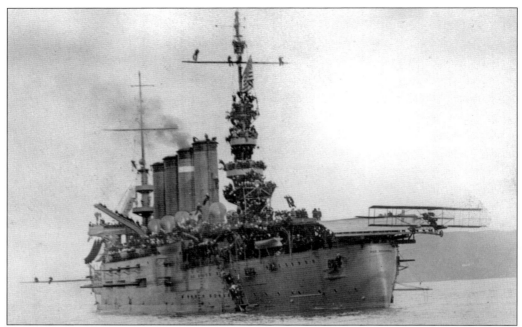

Curtiss pilot Eugene Ely made the first flight off a ship on November 14, 1910. The U.S. cruiser *Birmingham*, in Hampton Roads, added a makeshift flight deck for the experiment.

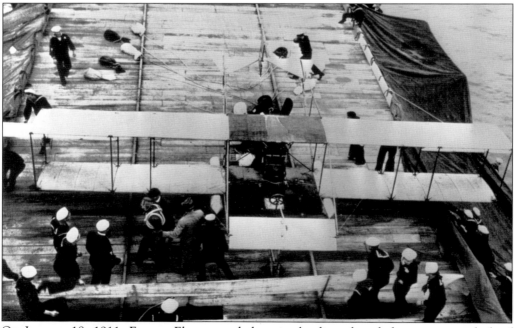

On January 18, 1911, Eugene Ely reversed the trip, landing aboard the temporary deck of the armored cruiser *Pennsylvania* in San Francisco Bay. The world's first shipboard landing employed a tailhook and arrester cables, a practice that continues to this day. Curtiss, Ely, and Hugh Robinson have all been credited with the idea. Like many of their innovations, it was probably a group effort.

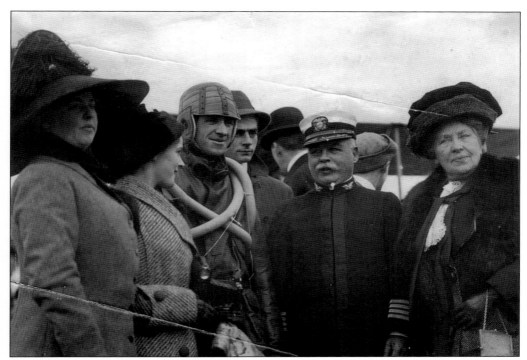

Captain Pond, Mrs. Pond, and Mrs. Ely are obviously delighted, but Eugene Ely seems to be brooding on the return flight.

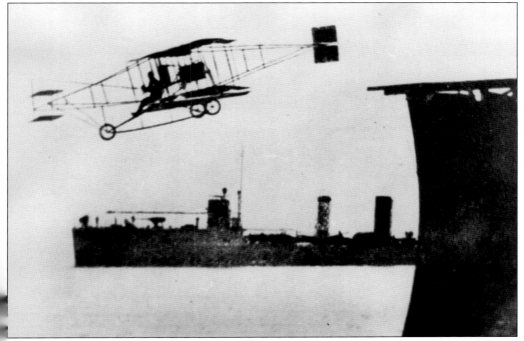

The day was a big success, but Eugene Ely died later that year at an exhibition flight in Macon, Georgia.

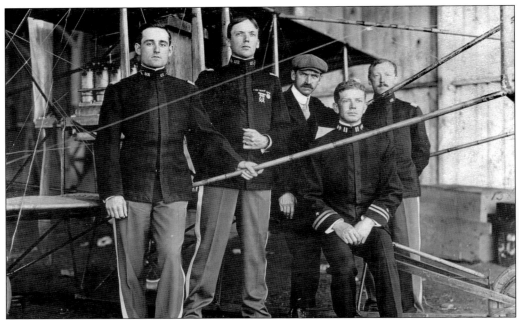

Curtiss established a winter camp at San Diego in 1910–1911. His offer to teach military officers free of charge produced four career men. With Curtiss in the center, they are U.S. Army Lts. J.C. Walker and Paul Beck, U.S. Navy Lt. Theodore G. "Spuds" Ellyson (who would soon be Naval Aviator No. One), and U.S. Army Lt. G.E.M. Kelly. Ellyson and Kelly would both die in crashes.

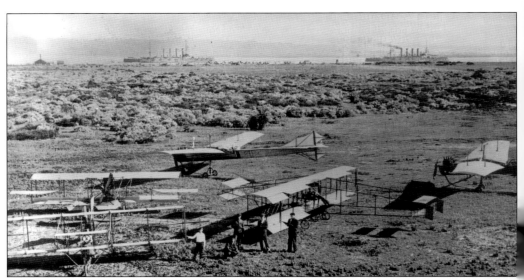

Who could have guessed how soon the descendants of those fragile flying machines would be sinking those mighty warships?

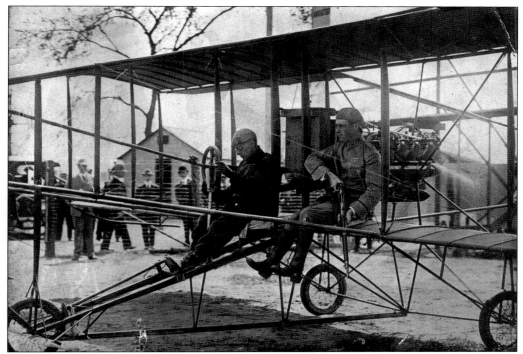

Curtiss pilot Charles Willard carried U.S. Army Lt. Jacob Fickel aloft to try airborne gunnery with his Springfield rifle.

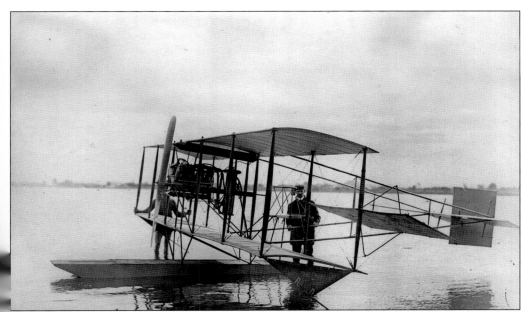

Curtiss was determined to crack the problem of water flying, and San Diego had the added advantage of being home port to the Pacific Fleet. He tried a tractor design, rather than his usual pusher propeller.

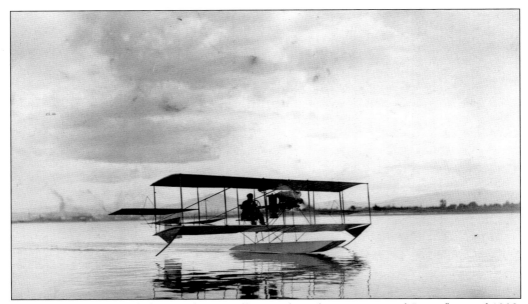

The float was at once lighter and more effective than the experimental *Loon* floats of 1908. Henri Fabre had flown from water the previous year in France, but his design was not practical and there was no follow-up.

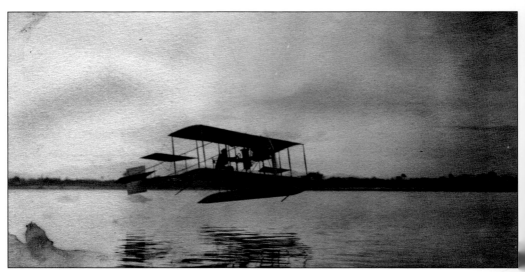

Curtiss startled himself by getting airborne and then signaled the *Pennsylvania*, now back from the Ely flight, and requested permission to fly out for a visit.

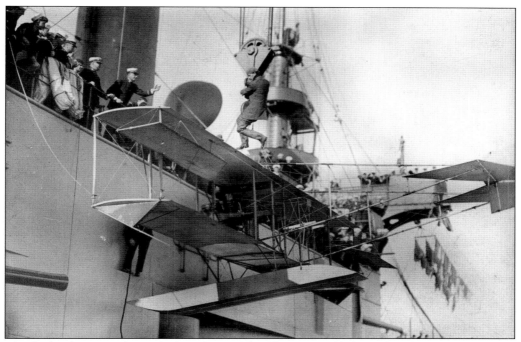

The hydroplane was hoisted aboard. Fearful of his own added weight, the athletic Curtiss clambered onto the hook.

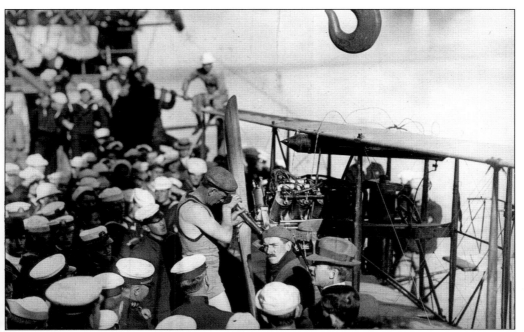

After a brief visit, Curtiss was lowered back to the water and taxied to camp. Navy officials quickly ordered him to build them a hydroplane.

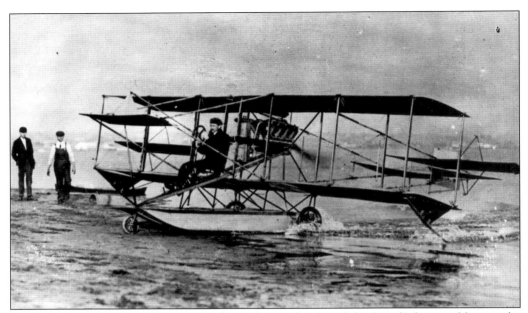

Working with Theodore Ellyson and others, Curtiss developed the "triad" design, able to go by water, sea, and land. The men returned to their accustomed pusher arrangement, which had obvious advantages for a seaplane.

Damon Merrill, one of the Curtiss crew, worked on the first retractable landing gear. Merrill's grandson Merrill Stickler was curator of the Curtiss Museum.

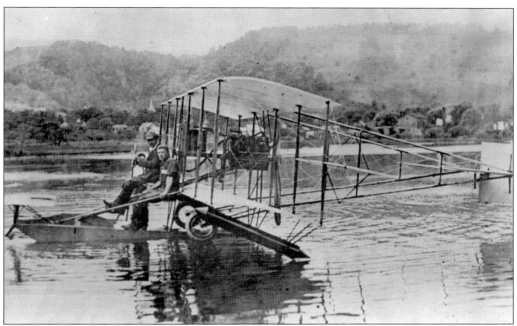

At Keuka Lake that summer of 1911, Theodore Ellyson took possession of *A-1*, the first naval aircraft.

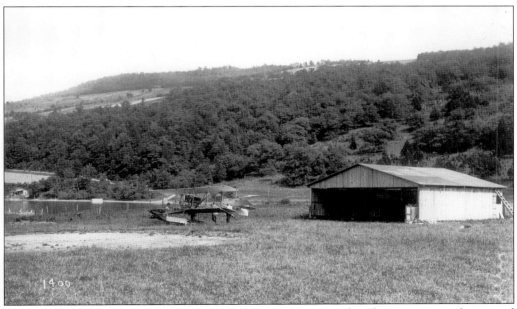

The first "naval air station" was the Curtiss Flying Field at Kingsley Flats, conveniently situated for land planes, seaplanes, and visiting tourists.

Assisting Theodore Ellyson was Lt. John Towers, who took lessons to become Naval Aviator No. 3. Towers would head the U.S. Navy Bureau of Aeronautics when World War II broke out. He later served as aviation chief and as chief of staff for Adm. Chester Nimitz, besides briefly commanding a carrier task force. Towers retired as commander-in-chief, Pacific.

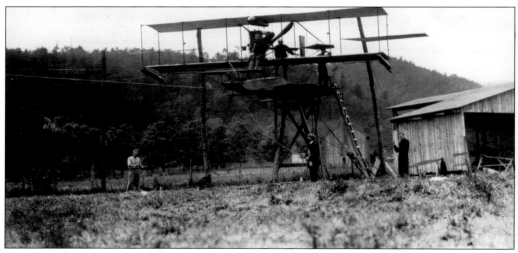

Wire launching was one of the many naval experiments in Hammondsport. Theodore Ellyson would later be killed flying a Loening seaplane across the Chesapeake Bay.

Curtiss was given American pilot's license No. 1 in 1911. He selected this image for his license photograph. Fellow aviators gave him precedence over the Wright brothers because he had made public flights before they did.

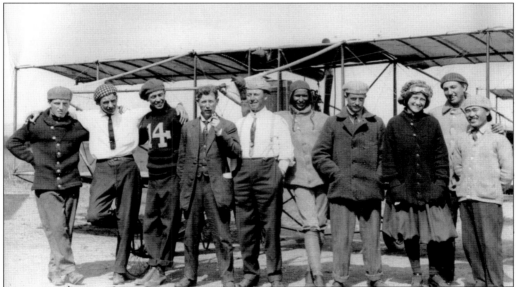

This 1912 class at San Diego included Floyd Barlow, John Kaminski, Floyd Smith, W.B. Davis, Roy B. Russell, Mohan Singh, Lanny Callan, Julia Clark, George Milton Dunlap, and Lt. Kono Takeshi. Kaminski billed himself as the world's youngest pilot, and Mohan Singh was called the only Hindu aviator. Julia Clark, the third woman to get a pilot's license, was the first woman killed in an airplane crash. Dunlap was involved in development of the OX engine, and Kono had been posted to Curtiss by the Imperial Japanese Navy. Their classmate Lieutenant Nakajima founded Japan's first private airplane factory. Nakajima airplanes and Curtiss airplanes fought each other across Asia and the Pacific in World War II.

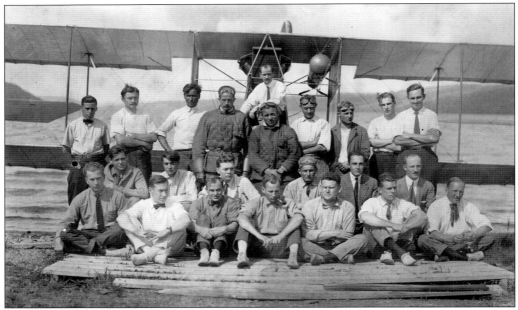

This 1913 Hammondsport class (including instructors) made a new constellation of aviation stars. Shown with Glenn Curtiss, who is in the far back, are, from left to right, the following: (front row) C.C. Witmer, Raymund Morris, Charles F. Niles, J.A.D. McCurdy, naval constructor Holden Richardson, Lt. (later, Adm.) Patrick Bellinger, and John D. Cooper; (middle row) Lawrence Sperry, Z.T. Barnes, Mortimer Bates, Leon D. "Windy" Smith, F.S. Gustenhofer, and Sir Haldeman Figelmessy; (back row) F.D. Lawrence, Frank Thalman, Mohan Singh, Lanny Callan, Francis "Doc" Wildman, J. Van Vleet, Frank Auckerman, Leon Englehardt, and Steve MacGordon.

Although he continued test flying, Curtiss gave up exhibitions in time for the birth of Glenn H. Curtiss Jr. in 1912.

Glenn and Lena Curtiss became reasonably prosperous, although the aviation business remained dangerously precarious.

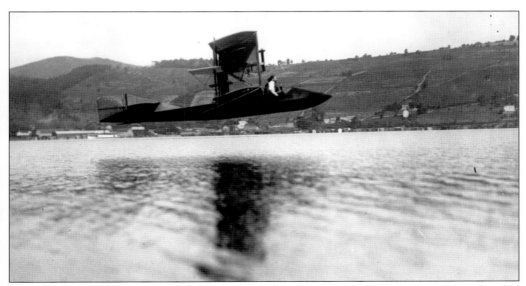

Continued water experiments led Curtiss to a safer, more commodious, and more comfortable seaplane—the flying boat.

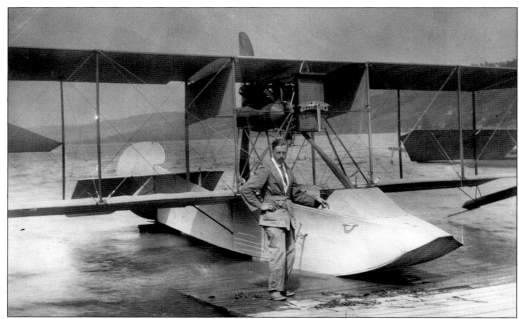

Logan A. "Jack" Vilas was the first of many millionaire sportsmen who took up "aerial yachting." Vilas used this 1913 craft to make the first flight across Lake Michigan. The hull, on loan from the Smithsonian, is now at the Curtiss Museum, along with museum's flying reproduction.

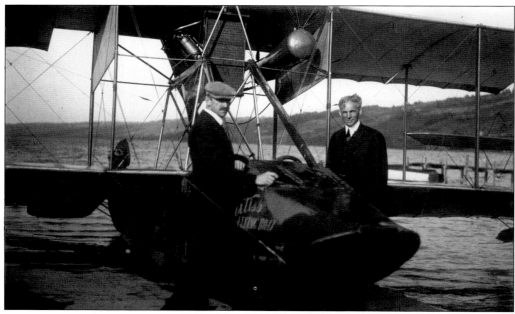

Even Henry Ford was fascinated by the flying boat. Ford was quietly helping Curtiss in his legal tangles with the Wright Company. He saw Curtiss's situation as similar to his own in fighting the Selden automotive trust when he founded the Ford company.

Agustin Parlá flew a Curtiss airplane from Key West, Florida, to Havana, Cuba. A Cuban postage stamp was later issued in his honor.

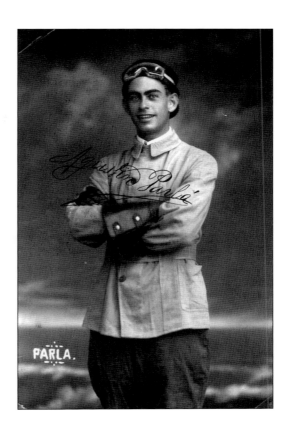

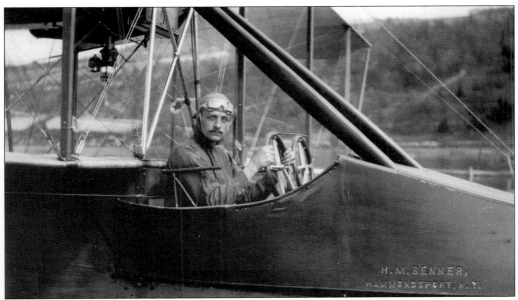

Curtiss flier Lansing "Lanny" Callan would represent the company in Europe during the Great War. Entering the navy, he eventually rose to admiral's rank.

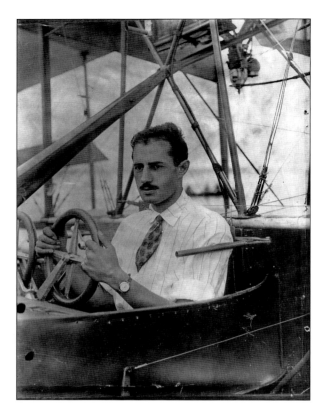

William E. "Gink" Doherty, who specialized in seaplanes, was one of Curtiss's best-known fliers. After his flying days, he worked for the Pleasant Valley Wine Company. Doherty's son Tony, himself a pilot, served as director of the Curtiss Museum.

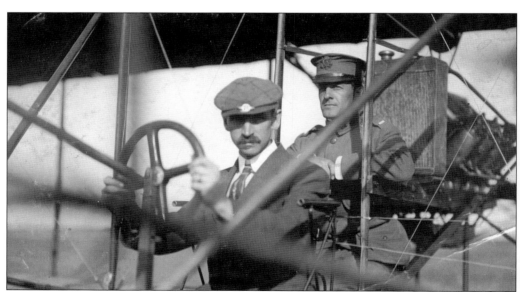

Each manufacturer had its own control system, and pilots could not change companies without retraining. Benjamin Foulois, who learned to fly on *SC-1*, became a Wright pilot. Controls were standardized just before World War I. Foulois later commanded the air corps.

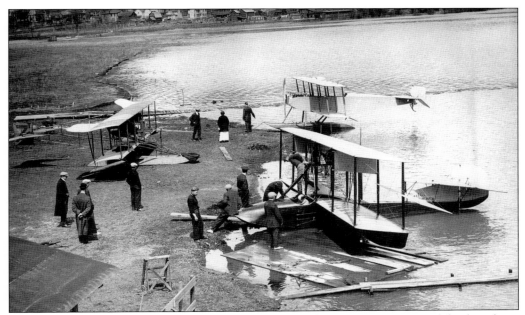

Publications extolled Hammondsport as "an aeroplane laboratory." It was one of the few places in America where airplanes were "as thick as fleas," as one visitor wrote. Natives affected a blasé air around tourists.

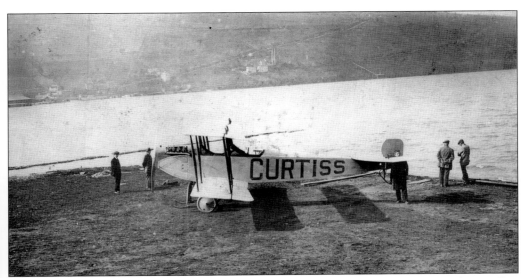

When Grover Loening condemned the army's entire stock of Wright and Curtiss pushers at San Diego, American makers were forced to modernize. Curtiss imported B. Douglas Thomas from England to design the Model J Scout.

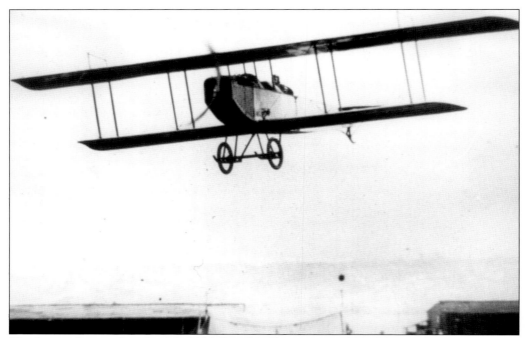

Blending in features from his Model N, Douglas Thomas created Model JN—the Curtiss Jenny.

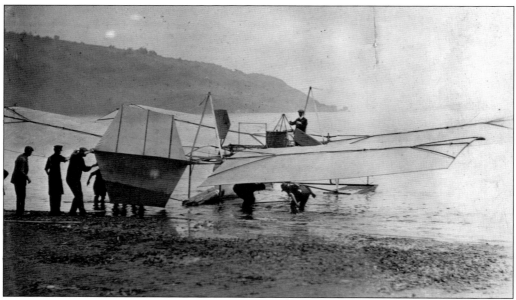

In 1914, the Smithsonian asked Curtiss to rebuild Samuel Langley's unsuccessful 1903 *Aerodrome* to see if it could have flown. Since "prior art" could theoretically weaken the Wright patent claims, Orville Wright was incensed (Wilbur Wright had died in 1912).

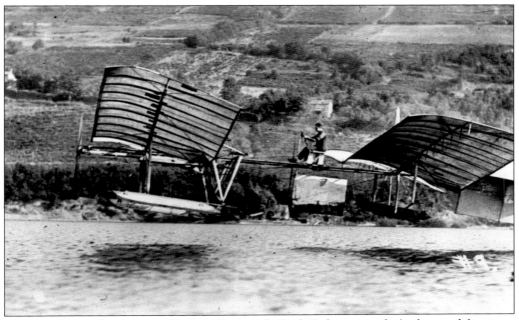

The Langley machine repeatedly flew (here with Gink Doherty as pilot) after modifications. Although these flights never entered the patent case, the bitter Orville Wright nursed a list of modifications. The Smithsonian announced that Samuel Langley's machine was the first to be "capable" of flight, and Orville Wright sent the Wright's first airplane to England, where it remained until a rapprochement after World War II.

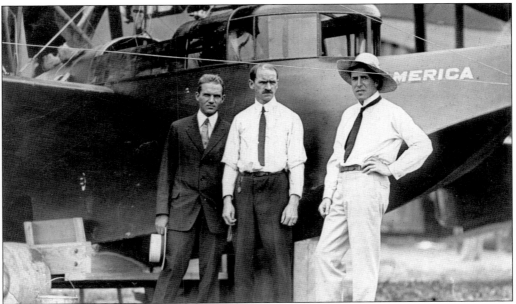

Also in the works that summer was the Rodman Wanamaker–financed *America*, a flying boat designed for the Atlantic crossing—10 years after Kitty Hawk. John Towers and Royal Navy Lt. Cyril Porte were tapped as pilots.

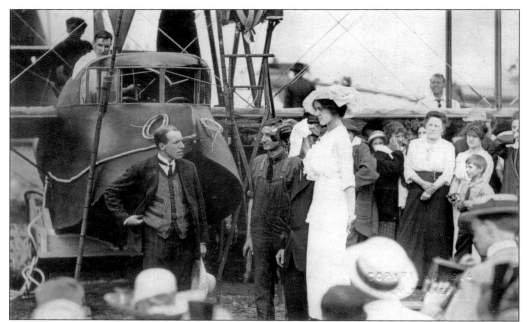

John Towers was ordered to take his airplanes and support American intervention in Mexico, where they took ground fire in naval aviation's first combat. He was replaced by George E.A. Hallet (to Cyril Porte's left), a Curtiss mechanic who could also take a trick at the wheel. Sixteen-year-old Katherine Masson christened the *America* with Great Western champagne.

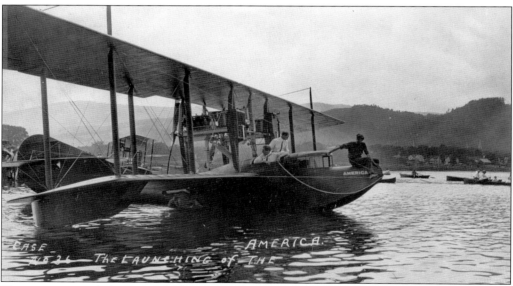

The twin-engined *America* could not get aloft with all the fuel needed for the trip. When reconfigured as the world's first trimotor, the third engine proved a nuisance in flight. Although this problem was still unresolved, Lanny Callan and others were on station at staging points from Newfoundland to the Azores. However, the trip was suddenly canceled, and Cyril Porte rushed home to England. Almost without warning, Atlantic crossings and Mexican skirmishes were dwarfed by global catastrophe.

Five

A CAPTAIN OF INDUSTRY (1914–1919)

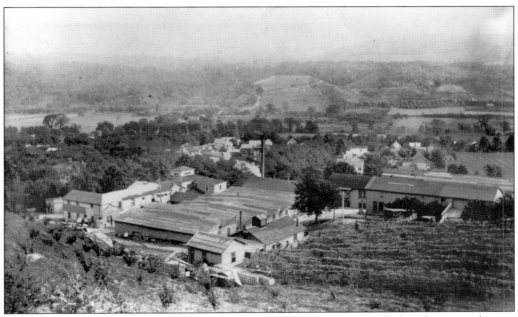

In 1909, Glenn Curtiss made the first sale of an airplane in America. Within five years, he was getting orders for hundreds, and then thousands, from the British and Canadian governments alone. From catch-as-catch-can buildings huddled around the Curtiss home in Hammondsport, the manufacturing end of the business alone grew to include gigantic factories in Buffalo; a subsidiary corporation in Canada, headed by J.A.D. McCurdy; a research firm on Long Island; and the former Burgess Company in Marblehead, Massachusetts. Subcontractors and licensees from Rhode Island to California churned out Curtiss products. The Buffalo plants even produced European designs to order. Only six of the firms given aviation orders on the U.S. declaration of war had made as many as 10 airplanes. The Curtiss Company, already the dominant player in America, quickly grew to dwarf all others combined.

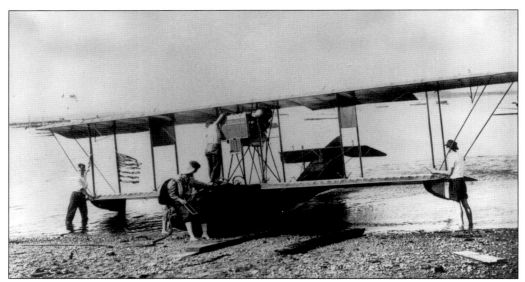

Curtiss was already a global supplier on a small scale when the Great War began. This particular flying boat went to the Imperial German Navy. The blockade and U.S. interests quickly ensured that trade was limited to the Allies and neutrals.

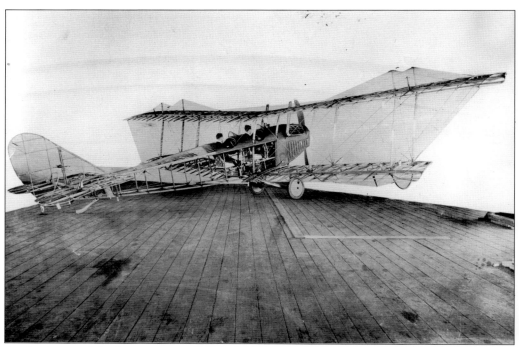

At the heart of the business was the Model JN Jenny in its various subtypes. Designed as a trainer, already in service, and available for mass production, the Jenny was an answer to British prayers. Britain and Canada placed large orders, with a still-neutral but increasingly nervous United States slowly adding to its own arsenal.

Engines, especially the 90-horsepower OX model, were demanded in even greater numbers than airframes. A truck from Hammondsport offloaded engines for export twice a day at the railroad station in Bath.

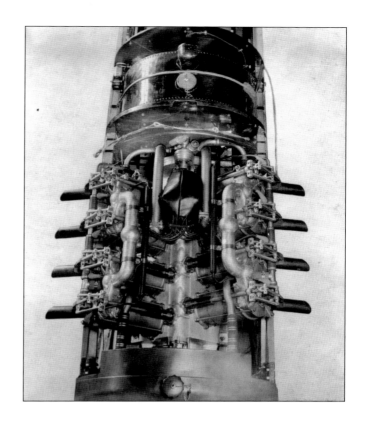

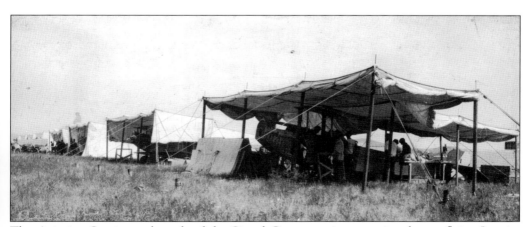

The Aviation Section, a branch of the Signal Corps, got its operational start flying Jennies from Texas into Mexico in quest of Pancho Villa. Benjamin Foulois got caught aloft in a thunderstorm once and had to kick a hole in the fabric to drain his cockpit.

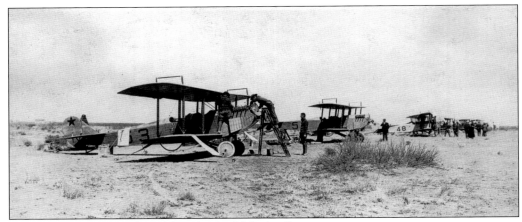

The red star was an early emblem for the U.S. Air Service.

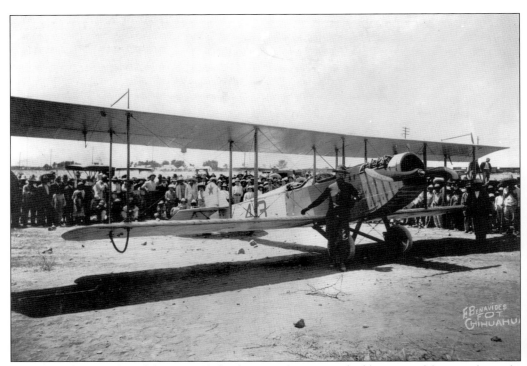

Maj. H.A. Dargue, forced down in Chihuahua, was being attacked by a crowd (notice the rocks on the ground) when a photographer appeared. The quick-thinking Dargue started posing, and the puzzled crowd settled down to watch the proceedings. Dargue, after promotion to general, was killed in an airplane crash at the beginning of World War II.

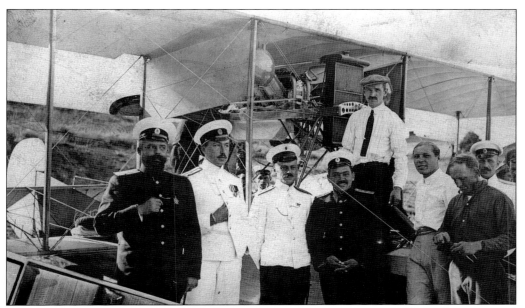

The Imperial Russian Navy was an enthusiastic user of Curtiss seaplanes. Glenn Curtiss visited before the war, and even considered the Russians' request to establish a plant in that country.

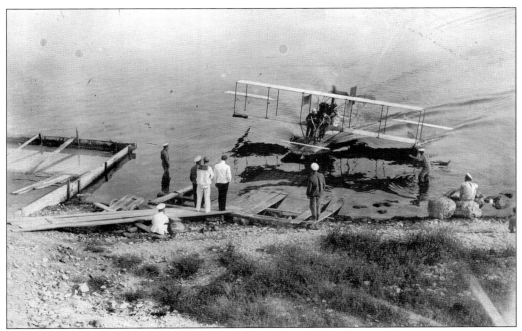

Contradicting a reputation for lumbering Russian military inefficiency, the Czar's navy was the only belligerent force to enter World War I with an established and tested doctrine for the use of airplanes.

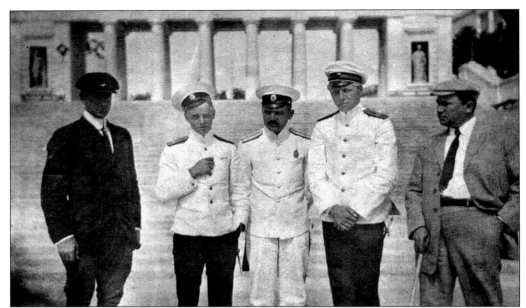

Curtiss pilot C.C. Witmer (left), one of the company's representatives in Russia, married the daughter of a military officer. After the Revolution, they fled the country in a small boat with their twin sons, following which Witmer joined the U.S. Navy. Both sons became U.S. pilots in World War II.

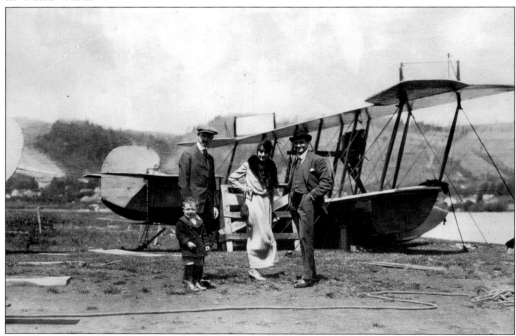

The Russians were extremely dissatisfied with their large purchase of K-boats like this one at the Hammondsport flying field. Delayed shipping had led to opened seams and other problems. The Bolsheviks may have repudiated the Czar's debts and obligations, but Joseph Stalin was still suing Curtiss-Wright over the K-boats after World War II.

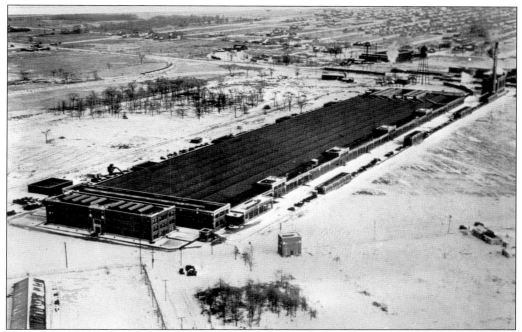

British orders forced Curtiss to open huge new facilities in Buffalo. Besides the large labor force (with amenities for the same), Buffalo offered simplified shipping to Britain and Canada. Supposedly, the British, through haste and misunderstanding, advanced 50,000 pounds for the new facilities, rather than the requested 50,000 dollars.

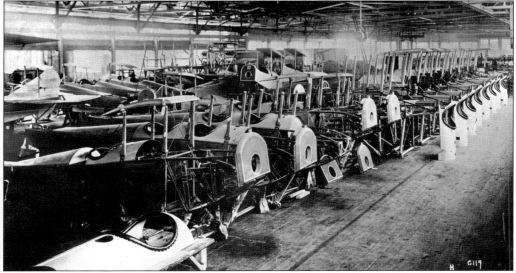

The Willys-Morrow automobile firm was brought in to apply mass-production methods to the manufacture of airplanes. Despite obviously impressive results, this proved far more challenging than anyone expected. Flying machines tend to be more complex than road vehicles.

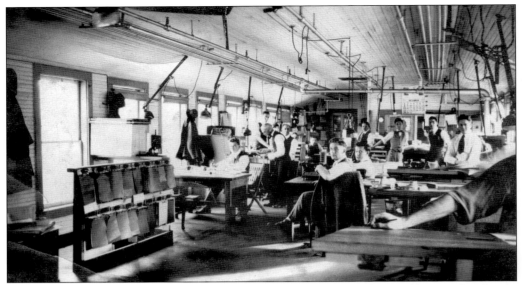

This office ran the original Hammondsport plant, now the smallest facility in the Curtiss empire. The last known veterans of the Hammondsport plant both died in 1997.

Hammondsport alone employed between 2,000 and 3,000 people, crowding an isolated village of 1,000 to the breaking point. Gone were the days of direct contact among all hands, with ideas circulating freely and airplane designs sketched out on the walls or floor.

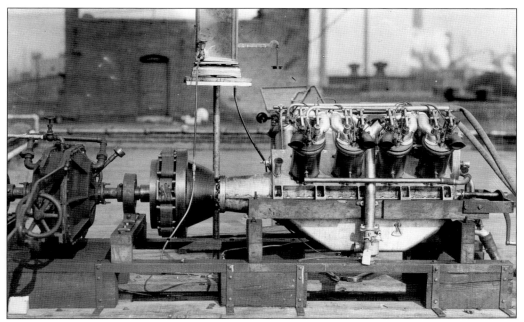

Hammondsport served as something of a prototype shop, but its main product became engines. So vast had the enterprise become that Hammondsport's entire production was used for export alone. The roar of engines on test stands could be heard five miles away.

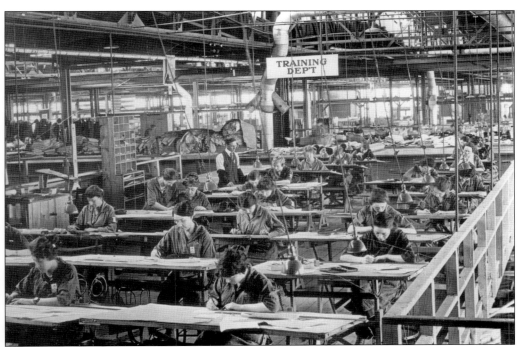

Women had been employed in the early days as office workers and in production as fabric workers. Now they entered the work force in large numbers and in new positions, especially after the U.S. declaration of war in April 1917.

Obviously, the lab foreman had to be up-to-date. Even 20 years earlier, the typewriter, telephone, electric light, and electric fan would have been less common and more primitive in an industrial office.

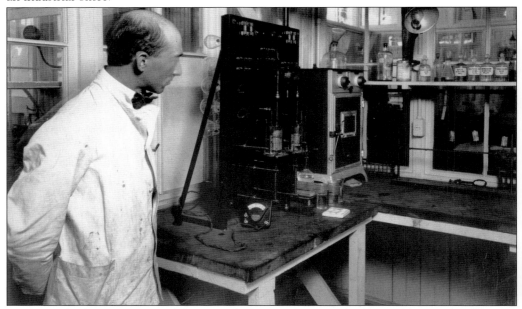

In the early days, Curtiss and his men had a tendency to build it and try it. While this reputation has been exaggerated (there is evidence of them modeling, wind tunneling, using standard values, and engaging in long calculations), things certainly became more scientific during this period.

Still, some operations remained startlingly simple. Stress was tested by shoveling gravel onto the wings and measuring resultant tensions.

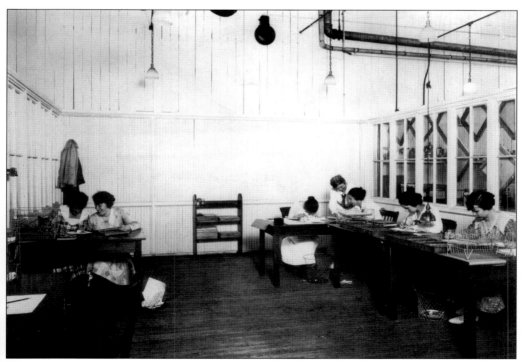

The computer room of 1916 bears no resemblance to a computer room today. These women were the computers.

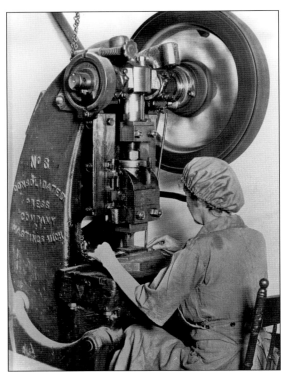

Rosie the Riveter, of World War II fame, owed a lot to her mother from World War I.

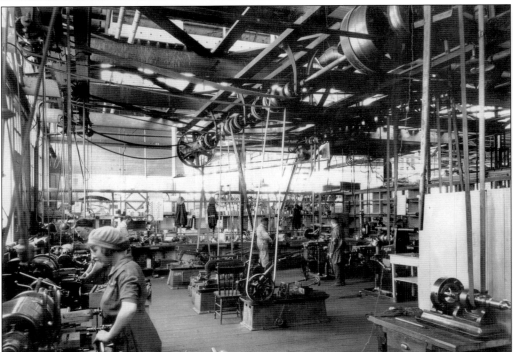

Like all contemporary factories, the Curtiss plants were noisy, with dangerous belt drives. They seem to have been well lit, though.

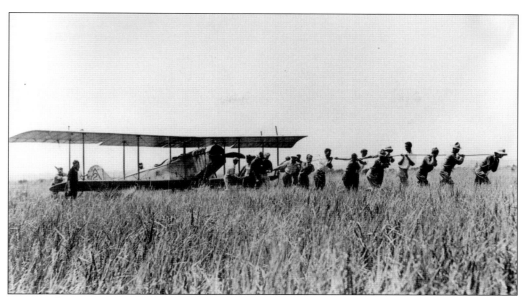

Curtiss flying schools, like this one in Miami, Florida, quickly became military flight-training schools.

Both army and Marine pilots trained in Miami. It is calculated that 95 percent of U.S. and Canadian wartime pilots trained on Jennies, which were also used in Britain and New South Wales.

Curtiss's friend Thomas Baldwin was in Virginia running the Newport News school when war broke out. Baldwin, born in the 1850s, went into uniform and finally became a real captain, living up to his nickname. In fact, Baldwin later rose to major at the Balloon Section in Ohio.

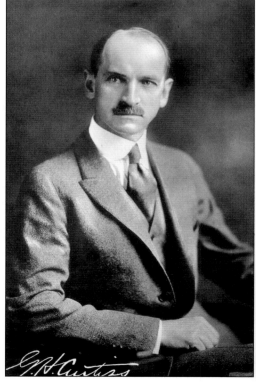

Curtiss was running a bike shop and harness business in 1901. After the Herring debacle in 1910, he was bankrupt and, in 1913, under pressure from the Wrights, he was still cash poor. When he sold controlling interest in 1917, he received $4.5 million in stock and $2.5 million in cash.

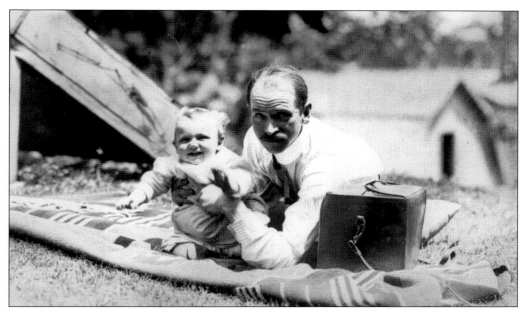

Having lost his first son, Carlton, in 1902, Curtiss was very solicitous of Glenn Jr. From the look of the camera, he had retained his old interest in photography. Quiet-spoken, straight-arrow Curtiss was in many ways a precursor of Lindbergh. In another eerie parallel, Glenn and Lena Curtiss were very concerned about their son being kidnapped.

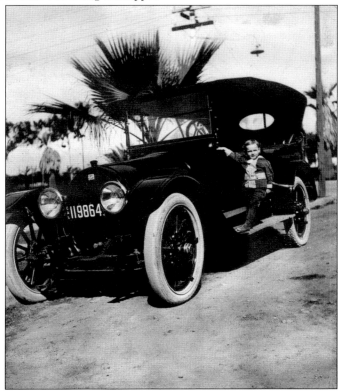

Curtiss liked fast cars, often rebuilding them with OX engines. Glenn Jr. appears to have shared his father's enthusiasm.

93

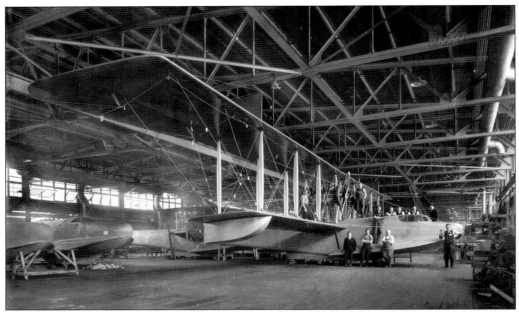

In 1914, *America* had been sold and shipped to Britain for naval patrols. Her erstwhile pilot, J.C. Porte of the Royal Navy, was a strong Curtiss supporter, and Winston Churchill a bulldog for naval aviation. Curtiss was ordered to build all the flying boats he could, as fast as he could. The H-series boats were follow-on designs from the original *America*.

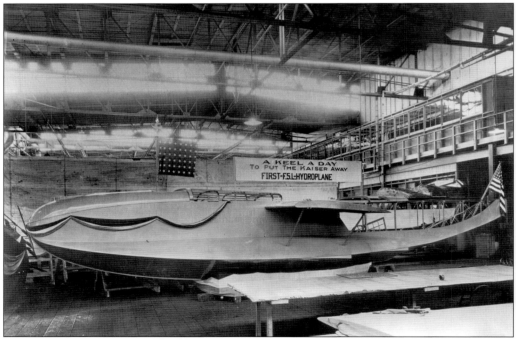

The F-5-L (not to be confused with the Curtiss Model F, a two-place flying-boat trainer) was a British Felixstowe design. American and British flying boats tended to be very similar, due to the close relations of Cyril Porte, Curtiss, and John Towers.

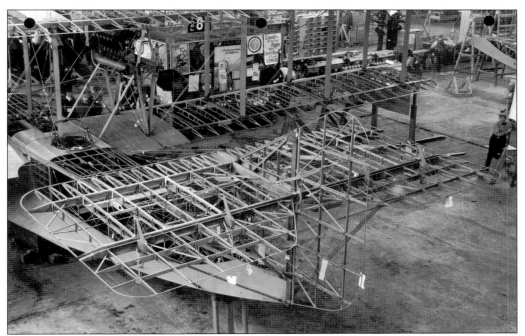

This view concentrates on the tail unit of the F-5-L. Note the marvelous patriotic posters in the background.

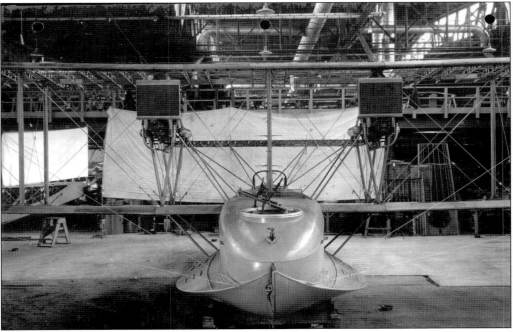

A Lewis or other machine gun could be mounted in the front cockpit, and there were also experiments with recoilless cannons. The wide sponsons on the lower hull contribute to stability in the water. Curtiss flying boats, used for reconnaissance, for bombing, and for U-boat patrol, were the only American-designed planes in World War I combat.

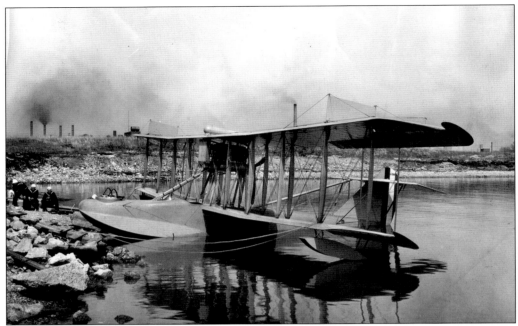

The HS series, powered by 12-cylinder Liberty engines, were designed to specifications drawn from British antisubmarine experience; over 1,000 were built. Many scholars have concluded that no aircraft ever sank a U-boat in World War I—but no convoy with air cover ever lost a ship. By keeping the subs down, the airplanes did their job.

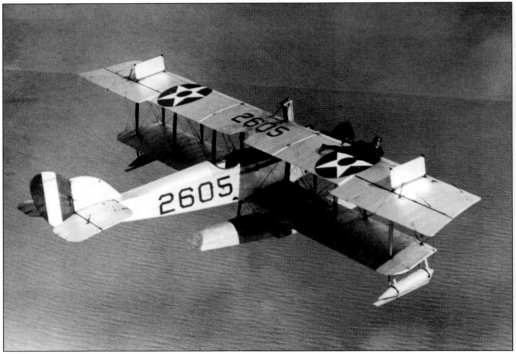

The N-series, essentially a JN Jenny with a single float, was a vital naval trainer.

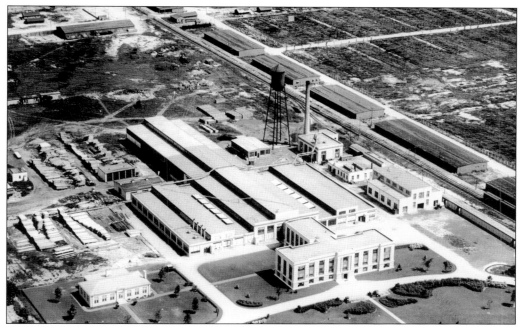

In 1917, Curtiss opened the Curtiss Engineering Corporation on Long Island. This subsidiary firm kept Curtiss and the top management in Buffalo out of each other's hair. The Engineering Corporation, under Curtiss, became the company's base for research, development, and prototypes. The white building on the right, three forward from the water tower, housed the world's largest wind tunnel.

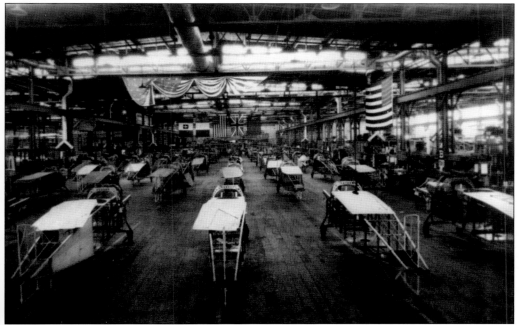

Notice the flags of the Allies. It was a patriotic time, and Curtiss workers often oversubscribed their Liberty Bond goals.

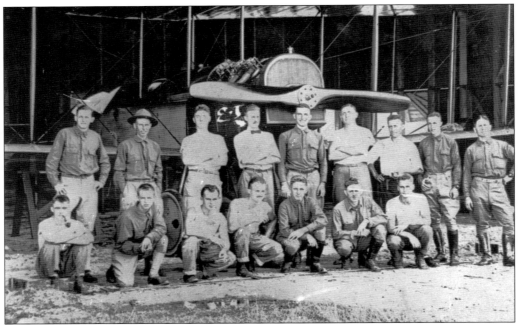

The Model R, sometimes described as a scaled-up Jenny, was designed because Jennies had trouble operating in the rarefied air of Mexico. Less remembered than the smaller Jenny, the Model R was used by both Britain and the United States.

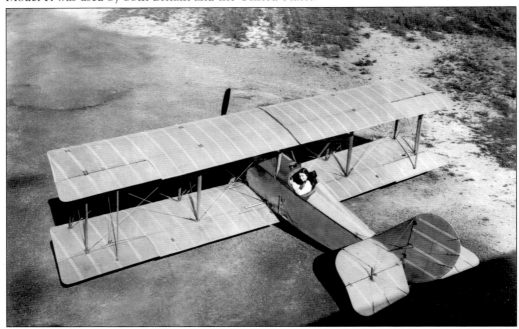

Civilian production continued until 1917. The Stinson Special was built for Katherine Stinson, who used it to set repeated world distance and altitude records. It had a Model S fuselage, JN-4 tail surfaces, custom wings, and an OXX engine. Stinson, the fourth woman to get a pilot's license, was one of the most expert pilots of her day.

Another 1917 offering was the Autoplane, yet another example of Curtiss's enthusiasm for hybrids. He designed the three-seater car, which could detach its Model L triplane wings and run on the road with its OXX engine. Supposedly, it made a few hops before it was shelved, probably with a sigh of relief, when war was declared.

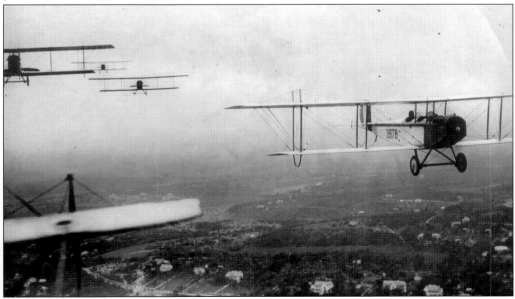

By 1918, predictions of American airplanes darkening the sky were beginning to come true.

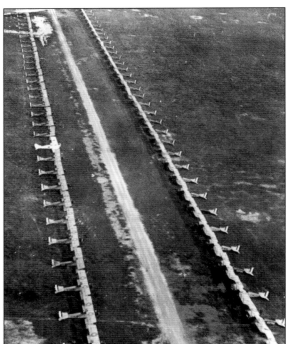

Production of Jennies alone ran to over 7,000 aircraft. The white one in the left row is an ambulance.

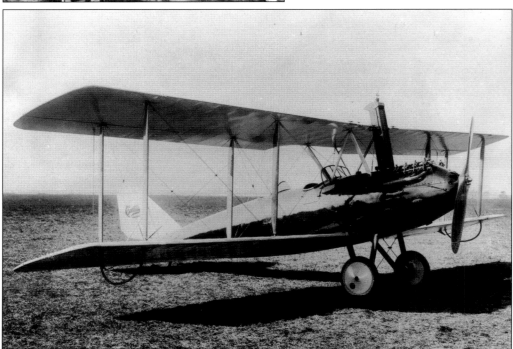

When the war ended, all facilities closed except the main plant in Buffalo and the Engineering Corporation. The peacetime Oriole was a smashing technical success, with its streamlined laminated wood fuselage, electric starter, and seating for three. It flopped in the marketplace because of competition from surplus Jennies.

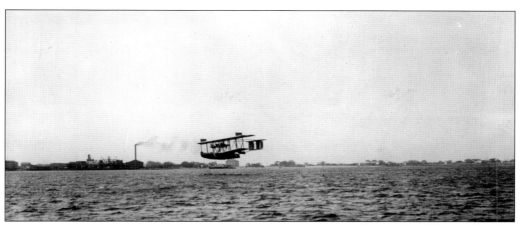

Telling Curtiss they wanted an airplane to fly the Atlantic, navy officials asked if it could really be done. "Of course it can," replied Curtiss. The huge NC (Navy-Curtiss) flying boats were completed and placed into service right after the war.

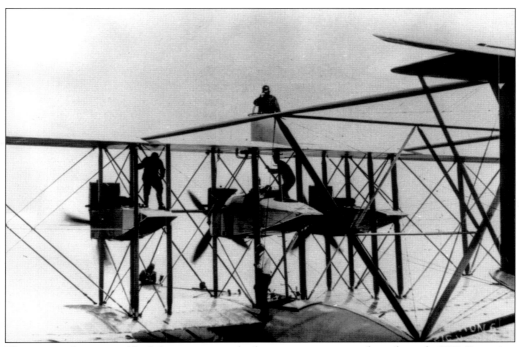

These aircraft, powered by Liberty engines, had a wingspan greater than that of a 737. By spring of 1919, *America*-project veteran John Towers was ordered to command a detachment of three on the first flight to Europe.

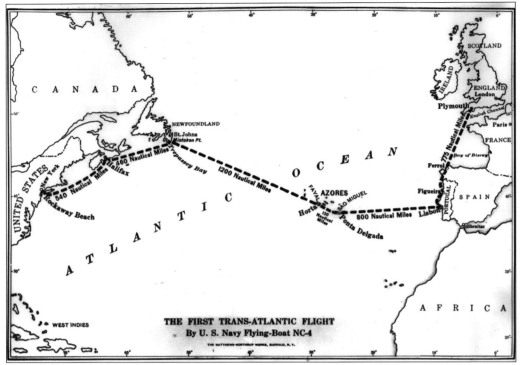

The route pretty much duplicated the planned *America* passage from five years earlier, canceled by the war.

NC-1, piloted by Marc Mitscher, was forced down and sunk by gunfire. John Towers's *NC-3* vanished and was feared lost until he brought it into harbor in the Azores, having taxied over 200 miles in a magnificent feat of seamanship, validating the very concept of the flying boat.

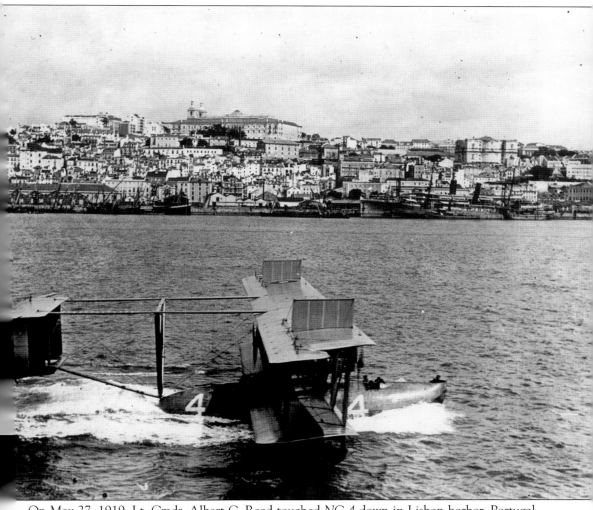

On May 27, 1919, Lt. Cmdr. Albert C. Read touched *NC-4* down in Lisbon harbor, Portugal. The *NC-4* would continue on to Plymouth, England, but it had already completed the first Atlantic crossing by air. The aircraft is now in the National Museum of Naval Aviation.

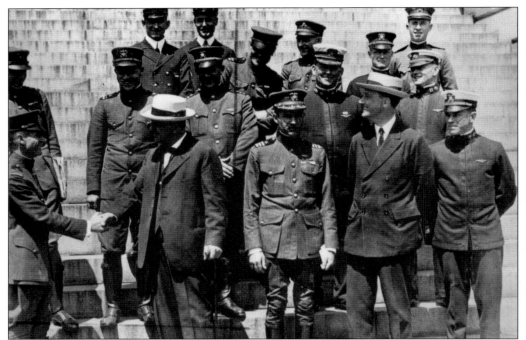

The officers and men were celebrated across two continents. Navy Department dignitaries offering congratulations included one of the mission's strong backers, Asst. Secretary Franklin D. Roosevelt. Roosevelt, as president, would later rescue the career of John Towers, a prickly, political officer being bypassed by admirals skeptical about the power of naval aviation. Towers, like Marc Mitscher, became a major architect of victory in the Pacific in World War II.

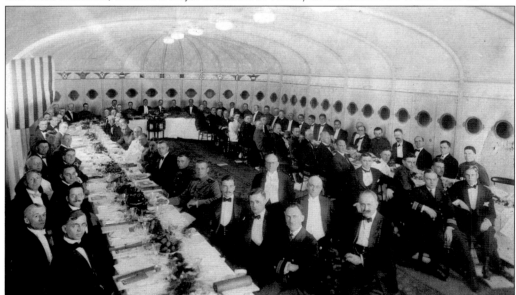

Glenn Curtiss dreaded formal dinners, but he sat at the head of the table for this celebration of the NC mission. Even as he hailed aviation's greatest triumph to date, his restive spirit was already drawing his eyes and his mind away from the skies.

Six

A LIFE OF INNOVATION (1919–1930)

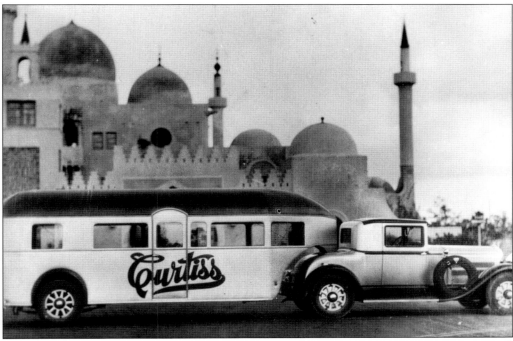

For Glenn Curtiss, the airplane business after World War I was "not very interesting." Accustomed to living his life on the busy shop floor and in the driver's seat of a speedy vehicle, he felt restless in the corporate boardroom. His businesses had always been extremely personal, and aeronautics had become impersonal. The modern aircraft was a scarcely recognizable grandchild of the flimsy flying machines with which he had stunned the world. Besides all that, he only had an eighth-grade education. Though he had learned plenty since that time, aeronautic engineering was no doubt getting past him. He would never completely leave aviation, just as he never completely left Hammondsport. But in the single decade of life left to him, he would always be seeking—and finding—new worlds to conquer.

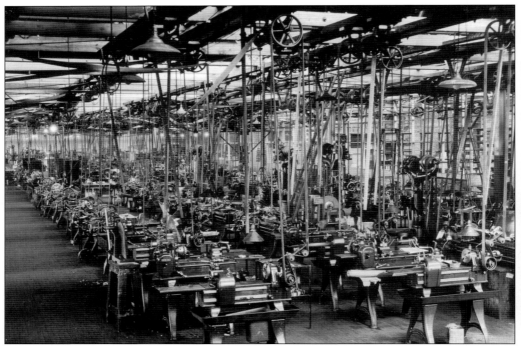

Despite the postwar economic troubles and the inevitable shrinkage of aviation orders, the Curtiss Company still controlled about 75 percent of America's aeronautic business.

The Curtiss Eagle, a laminated-wood, enclosed-cabin biplane seating eight, was one of the first passenger liners.

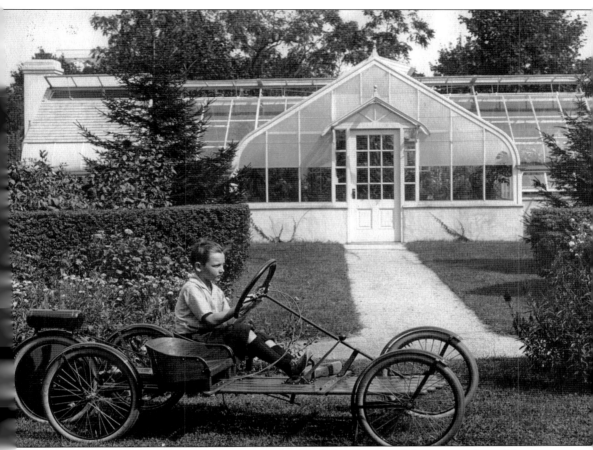

While retaining their Hammondsport home, the family lived most of the year on Long Island, where Curtiss was president of the Engineering Corporation. Glenn Jr. is shown seated in a Smith Flyer, the smallest auto ever mass produced. The wheel on the rear centerline has a one-cylinder engine. Despite the vehicles in their garage, Curtiss and his wife continued to enjoy bicycles, and he often cycled to work.

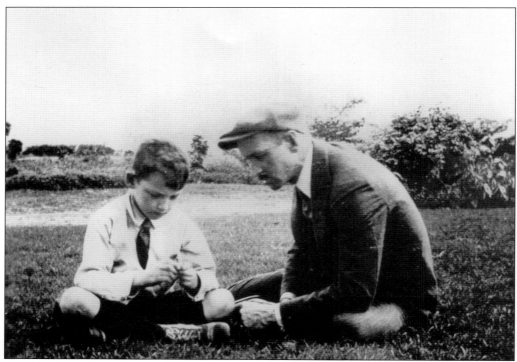

Glenn Jr. remembered his father as a kind man, who had taught him to hunt and fish. Kindness was very important to Curtiss, who had suffered repeated losses in his personal life.

Curtiss was watching younger men set records. On this day, Roland Rohlfs set a new altitude record in a Curtiss Wasp, with engine and airframe largely the creation of Charles Kirkham.

The Curtiss Racers, operated by such legendary pilots as Bert Acosta (right), Billy Mitchell, and Jimmy Doolittle, set the world standard for speed and for clean design.

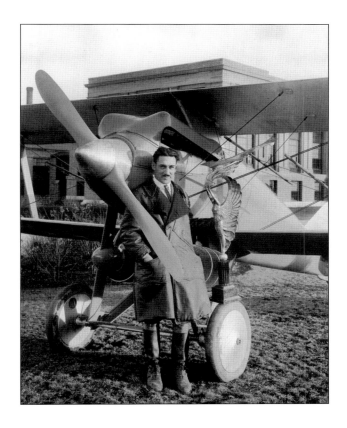

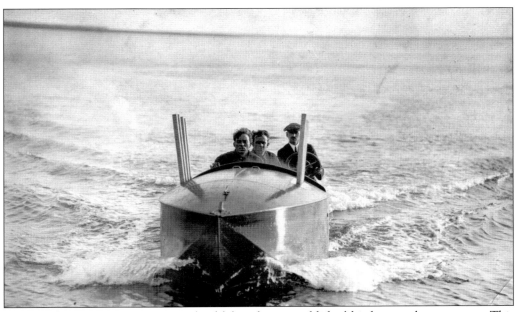

Curtiss, who grew up on a major inland lake, always established his homes close to water. This boat, with no small engine, judging from the exhaust stacks, was photographed near San Diego.

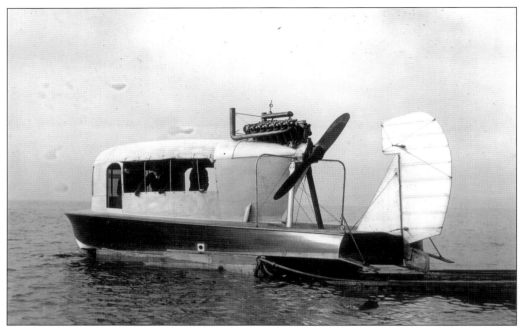

Before the war, Curtiss had established a seasonal flying school near Miami, Florida, and soon began spending more and more time in that area. *Miss Miami* was a shallow-draft vessel with an air propeller, forerunner of the airboats that would crisscross the shallow waters of south Florida. *Miss Miami* set a world speed record in 1917.

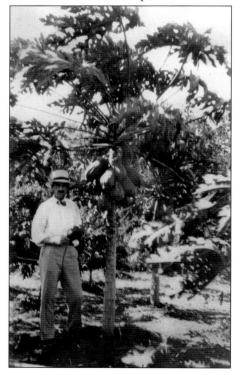

James W. Bright had turned flatlands west of Miami into grazing land. Curtiss bought out Bright's brother to become a partner in the ranch. The two men enthusiastically bought adjoining parcels whenever possible. Curtiss experimented with exotic fruits, including papayas.

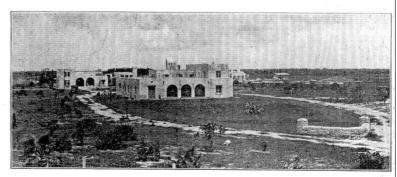
Besides encouraging development of the community, which they named Brighton, the partners created a planned development on their grasslands. Talking to some of the local Seminoles, Curtiss learned that they called the region Hialeah. The Florida land boom was just beginning. Glenn Curtiss and James Bright flabbergasted themselves by selling $1 million worth of lots in 10 days.

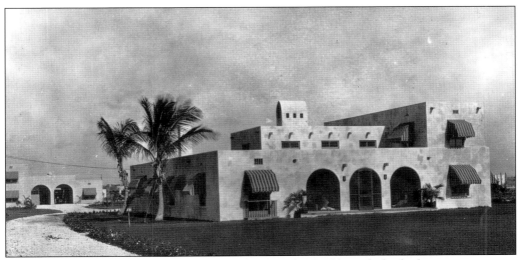

Curtiss built himself a house in Hialeah, adopting the Pueblo style he had seen on visits to the southwest. His stay would be short, but his architectural choice would soon resurface on a grander scale.

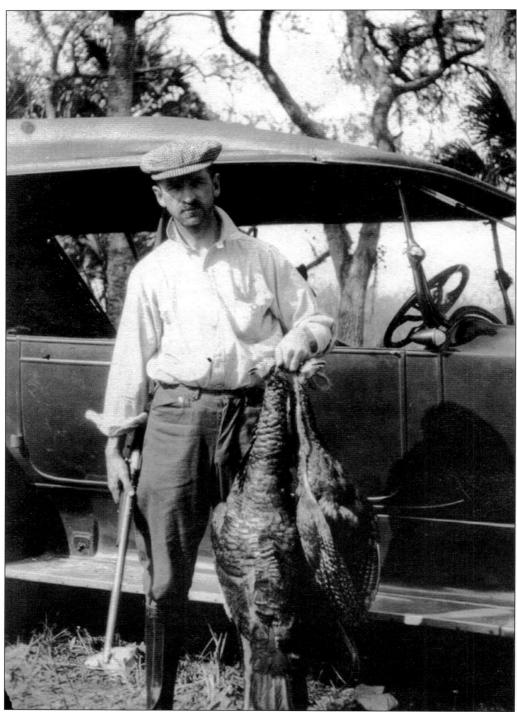

Always athletic, always enthusiastic about the outdoors, Curtiss escaped business pressures by hunting. He once rented a grouse moor in Scotland, but more frequently went after turkey in the Florida Everglades.

Alligators were considered a problem in south Florida. They were often captured and relocated to areas where they were less populous.

On one occasion in the Adirondacks, Curtiss spent the day wearing one boot and one shoe to test a campfire dispute about which type of footwear better suited the terrain.

Curtiss labeled this photograph "Bandit Camp."

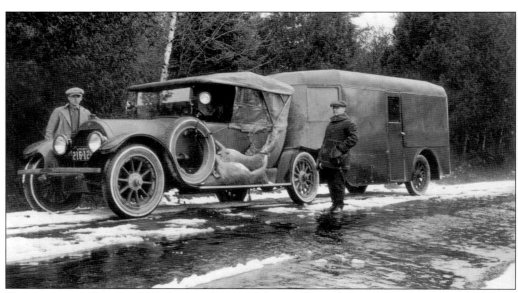

His camping enthusiasm, and America's growing love affair with the auto, inspired a new Curtiss creation: the Adams Motor Bungalo, named for his partner and half-brother, G. Carl Adams.

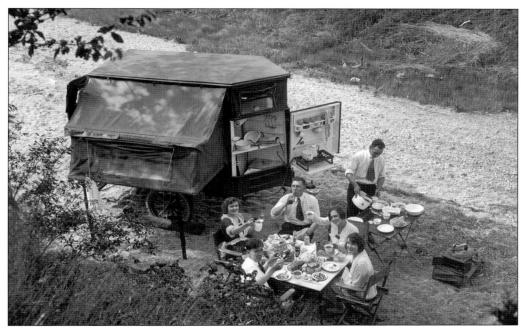

Unlike other trailers appearing about this time, the Motor Bungalo featured a hard roof and streamlining, no doubt inspired by Curtiss's aeronautical design experience.

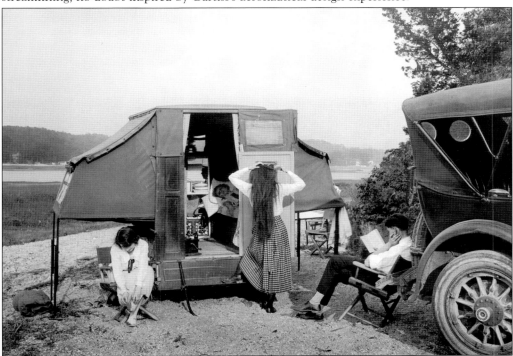

The Motor Bungalo gave Americans a freedom, with comfort, they had not previously enjoyed. Camping became an important part of weekends and vacations, as well as a market for new innovations.

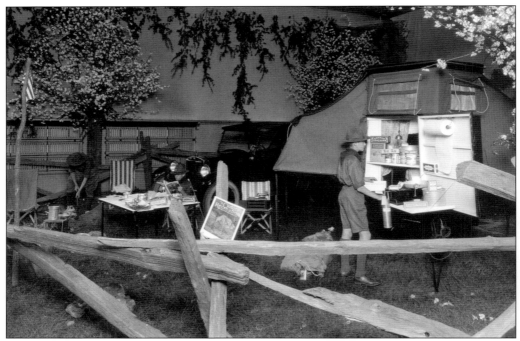

The Motor Bungalo business petered out in postwar hard times, but it would not be forgotten. Here a Boy Scout troop demonstrates comforts not usually found around a campfire.

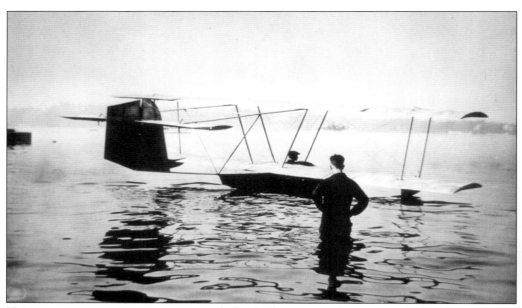

Having gotten extensive experience with the shallow waters of south Florida, Curtiss conceived and flew the flying boat glider, which he saw as the basis of a new sport.

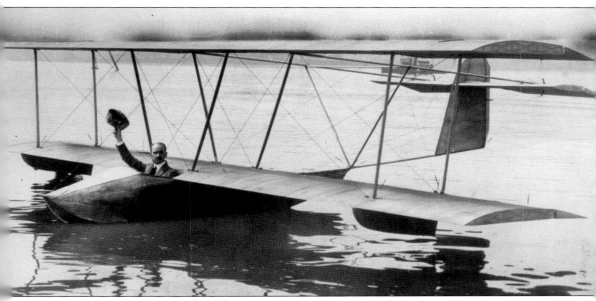

It worked, but it did not catch on.

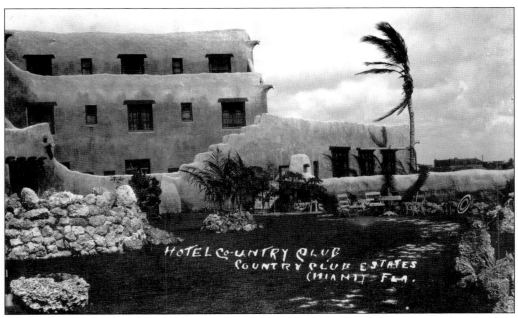

Glenn Curtiss and his partner James Bright now envisioned a development even grander than that of Hialeah. They anchored it with a golf course, which they turned over to the city of Miami, along with its abundant supply of fresh artesian well water. In 1930, residents changed the name to Miami Springs.

Country Club Estates was planned as a "themed" development, with public buildings and homes in the Pueblo style. Glenn and Lena Curtiss built a $150,000 house and spent $80,000 to decorate and furnish it. The grounds included a terraced swimming pool and a pond for waterfowl. Lena Curtiss named the home Dar-err-aha, or "House of Happiness." The couple had come a long way from the bike shop.

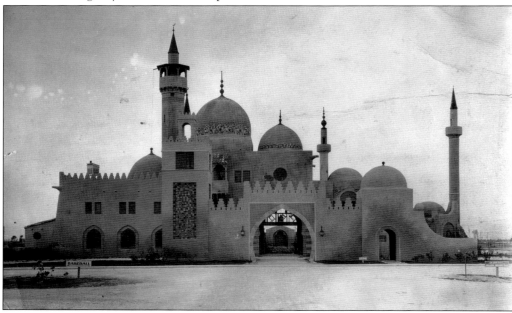

The city of Opa-Locka drew its name from a Seminole phrase describing a high, dry, hammock of ground. This city was to have an Arabian Nights theme. Curtiss donated land for airports in both Opa-Locka and Hialeah. Both of those airports are still active, and one has evolved into Miami International.

Since his home adjoined the country club, Curtiss tried golf but never really took to it.

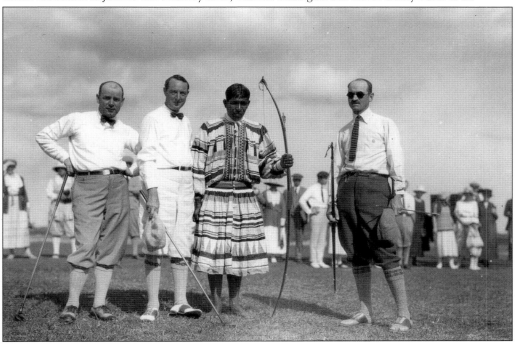

Instead, Curtiss took up archery and then archery golf—going around the course, starting from each tee with the golfers and shooting through upright rings on the greens. He often went around with the pros—they driving, he shooting—and beat their scores.

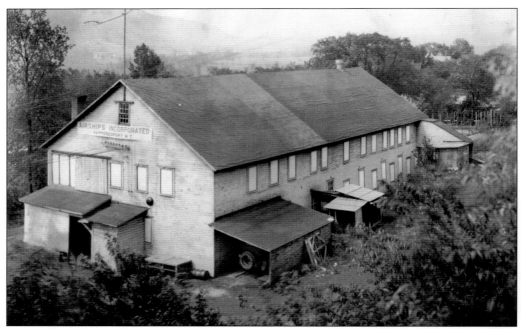

When the 2,000-employee Curtiss Hammondsport plant closed in 1918, it was a staggering blow to the Finger Lakes village, which was simultaneously losing its other main business—vineyards and wineries—to Prohibition. Curtiss promoted a number of businesses in the old facility, including Airships Inc. None of the new businesses endured.

HELP · WANTED

WOMEN & GIRLS

Needed immediately for steady employment in fabric department. No machines used. Clean work in well lighted rooms.

Pleasant surroundings and an ideal chance to spend the summer on Lake Keuka.

APPLY TO

Airships Incorporated

Hammondsport, N. Y.

Telephone 49 or write

Fabric work for women was a long tradition in the Curtiss plant. It was obviously a prominent feature of the lighter-than-air business.

120

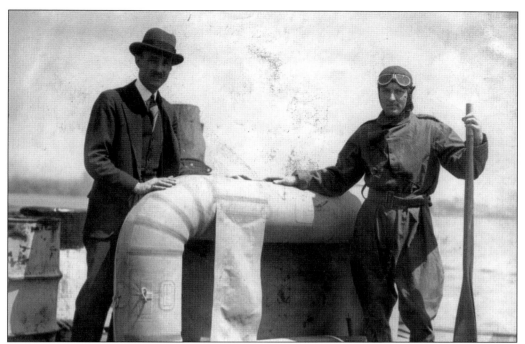

Airships Inc. was run by Curtiss veterans Lanny Callan, Gink Doherty, Beckwith Havens, and C.C. Witmer. The old team worked with lighter-than-air craft and allied technologies, notably inflatable rafts. Shown with one of their rafts are Becky Havens and Richard Byrd.

Henry Kleckler, Curtiss's righthand man for years, founded the Aerial Service Corporation, buying and selling parts for surplus Jennies. Kleckler did not stay long with the firm, which was eventually renamed Mercury Aircraft. Today, some 80 years later, Mercury is the Hammondsport area's major employer, an indirect legacy of the old Curtiss days.

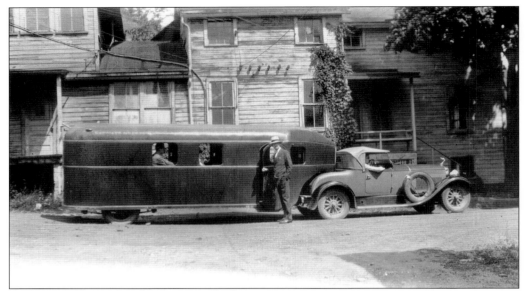

Curtiss may have used the old facility to create the prototype for a new incarnation of the Motor Bungalo, the Curtiss Aerocar.

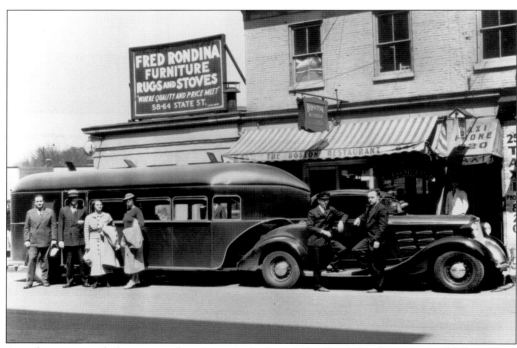

Aerodynamic and futuristic, the Aerocar had a fifth-wheel hookup. It could be towed comfortably in excess of 50 mph. This tow car is a Reo.

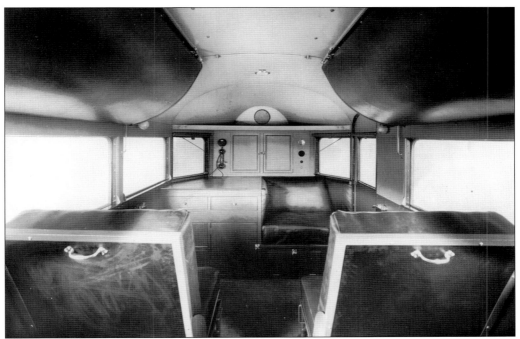

Lavishly appointed, an Aerocar cost $6,000—a lot of money during the Great Depression.

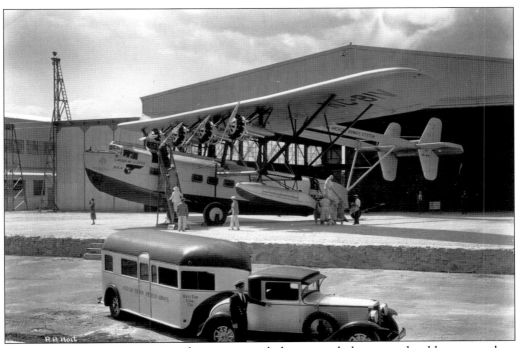

The Aerocar came in various configurations, including an ambulance, a school bus, a tour bus, and a horse trailer. This airport limousine is meeting a Sikorsky flying boat passenger liner.

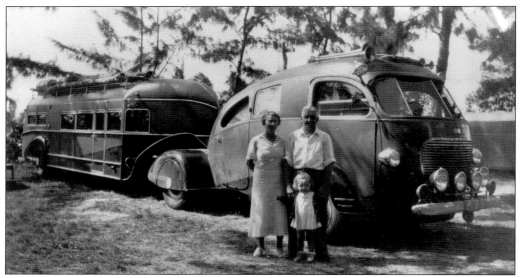

Curtiss "land yachts" were definitely a luxury item.

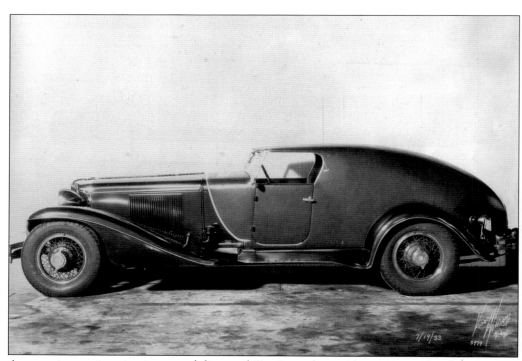

Automotive engineering in general disgusted Curtiss as sloppy when compared with aeronautic design. He rebuilt autos, adding airplane engines for the speed he craved and experimenting with innovations such as independent suspension and front-wheel drive.

Curtiss was disappointed that Glenn Jr. did not follow his footsteps into engineering. The son eventually did quite well, however, in the Volkswagen business.

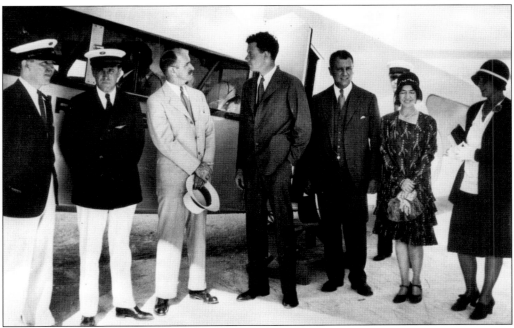

Curtiss himself remained involved with his original aviation business, although more and more he was there only as a sort of elder statesman. When he met Charles A. Lindbergh, he doubtless remembered the days, scarcely a decade earlier, when he and a handful of others had dared to make Atlantic flight a reality.

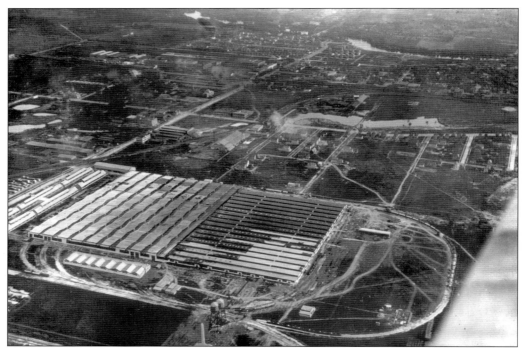

C.M. Keys controlled the corporation. He established airports, flying schools, and flying services, meantime gaining strong stock positions in several airlines. In 1929, Keys engineered the massive merger creating the Curtiss-Wright Corporation, the second-largest company in America. Curtiss, still a significant shareholder, served on the technical committee.

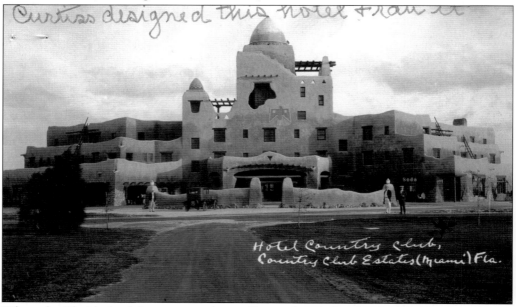

Curtiss designed this hotel + ran it

Hotel Country Club, Country Club Estates (Miami) Fla.

When the Florida land boom petered out, Curtiss found that his Pueblo Hotel could not support itself. He turned the facility over to his new friend, nutrition activist J.H. Kellogg, for $6. Kellogg used the hotel suites to establish a sanitarium.

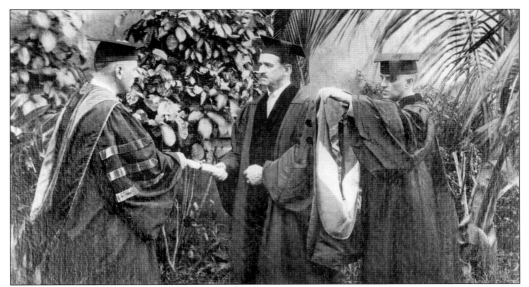

Curtiss founded 18 corporations in Florida, served on civic commissions, donated extensive land and water rights, and vigorously promoted the growth of the Miami region. In the spring of 1930, he received an honorary doctor of science degree at the University of Miami's second commencement.

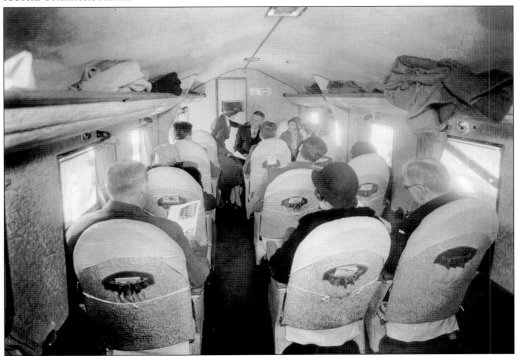

In May 1930, Curtiss was celebrating his 52nd birthday and the 20th anniversary of his flight down the Hudson. He would repeat this route in a new 18-passenger Curtiss Condor airliner, with a professional pilot handling takeoff and landing. His wife and son were aboard, along with Henry Kleckler, Augustus Post, and various dignitaries.

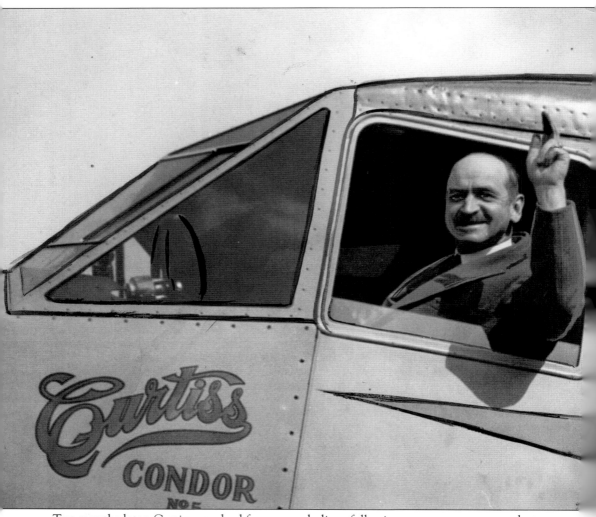

Two months later, Curtiss was dead from an embolism, following an emergency appendectomy. Glenn Hammond Curtiss was buried beside his father, his grandparents, and his infant son in Pleasant Valley Cemetery, within sight of the ground from which he flew *White Wing* and *June Bug* 22 years before. Great men of the world and old friends from the village stood by as airplanes dropped flowers on the crowd.